peanut butter
dogs

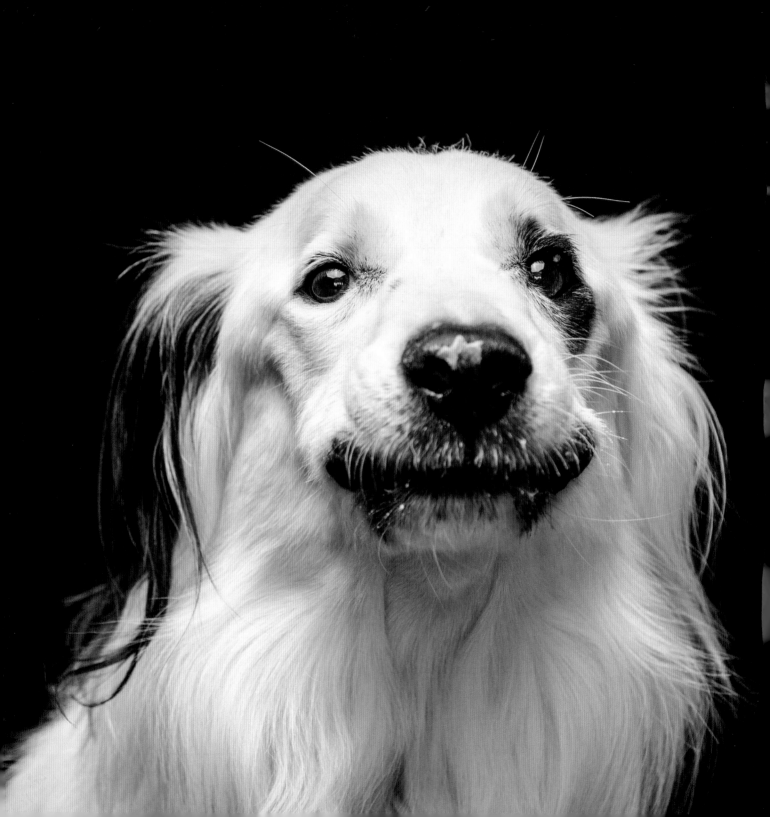

peanut butter
dogs

Photographs by Greg Murray

GIBBS SMITH
TO ENRICH AND INSPIRE HUMANKIND

21 20 19 18 17 5 4 3 2

Published by
Gibbs Smith
P.O. Box 667
Layton, Utah 84041

1.800.835.4993 orders
www.gibbs-smith.com

Designed by Rita Sowins
Printed and bound in Hong Kong

Gibbs Smith books are printed on either recycled, 100% post-consumer
waste, FSC-certified papers or on paper produced from sustainable PEFC-
certified forest/controlled wood source. Learn more at www.pefc.org.

Library of Congress Cataloging-in-Publication Data
 Library of Congress Control Number: 2016947096

ISBN 978-1-4236-4665-5

Dedicated to Bailey, and to all animals currently waiting to find their forever homes.

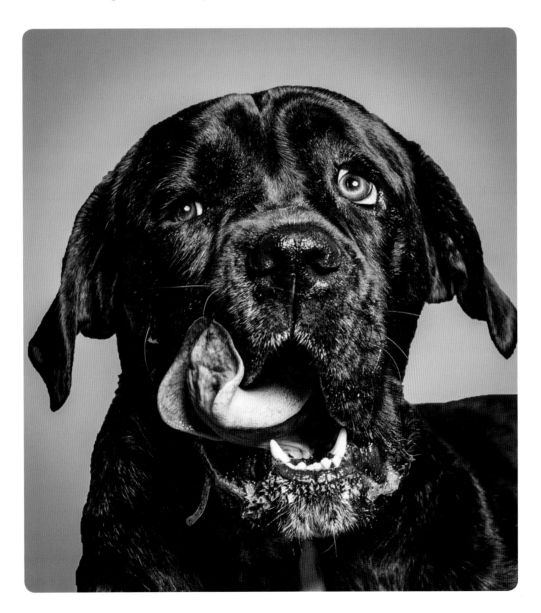

Introduction

My number one job as a photographer is to make people smile—it's the best part of what I do. However, I haven't always been in this profession, and it took me a long time to have the courage to pursue it.

I spent ten years working in corporate America, firing or laying people off from their jobs, putting out office fires, and rummaging through large amounts of paperwork. Spending much of my time in a windowless office five days a week, my mental and physical health began to suffer. I needed a change, and so did Kristen (my girlfriend at the time, now my wife). If I hadn't made a change, I'm not sure Kristen and I would be married today.

I left that job in early 2014, and a few months later, I was a full-time pet photographer. Combining my love for photography and dogs was only natural for me. Two short years later, I began working on this book. Life is full of unexpected turns.

On the surface, this book appears to be about dogs and peanut butter. However, my true intention is to promote joy. Dogs and peanut butter are simply the subjects for doing so. Isn't it amazing how dogs can make us happy? If you have a dog, you know the feeling of coming home after a long day to find your furry one excited to see you, cuddle with you, and love you without hesitation. Anything negative about your day will be quickly in the past. Dogs have the ability to change our moods in an instant, and we are lucky to have them as our constant companions.

In September 2013, my wife, Kristen, and I adopted our first dog, Leo, from the Cleveland Animal Protective League. In May of 2014, we rescued our second dog: Bailey the Mastiff. Bailey was about a year old when we adopted her, and while we don't know all the details, the first year of her life was far from easy. She came to us in pretty bad shape having been rescued out of a backyard breeding situation. She was very underweight and scared, and it was our job to give her the best life possible.

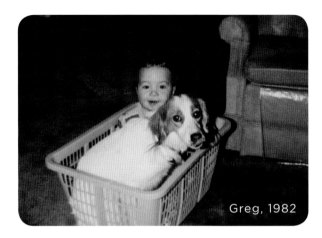

Greg, 1982

Although she only lived to the age of two and a half, we were able to give her more than a year of joy and adventure. She loved wrestling with Leo, drooling all over our home, and hiking in Cuyahoga Valley National Park. In return, Bailey was able to give you this book. She was its inspiration, and my very first peanut butter photo.

I didn't know it at the time, but Bailey would be the first of more than one hundred fifty dogs that I would photograph eating peanut butter. More than 80 percent of the dogs photographed for this book are rescues, just like Bailey, or in foster homes waiting to be adopted into their forever home. If you weren't thinking about it already, I will ask you to consider adopting a dog (or two!) in need of a forever home. As you read this, thousands of dogs are in shelters and foster homes, waiting to give you their gift of love. Sadly, every day many of these noble animals are put down due to overcrowding. You can make a difference by adopting, volunteering, and/or donating to benefit your local animal shelter.

Bailey's original peanut butter photo, the genesis for this project, still brings smiles to people's faces today. When you walk into our house, a large canvas print of her greets you. Bailey, and her photo, will forever be a part of our lives.

As you move through the pages of this book, I hope that you find the dogs' joy to be contagious. I hope you smile, laugh, and share it with someone you love. Bailey, for whom this project is dedicated, lives on in this book every time it makes you smile. So, please: Sit. Stay. Fall in love with this book.

—Greg Murray

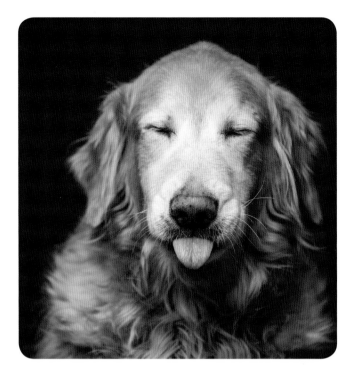
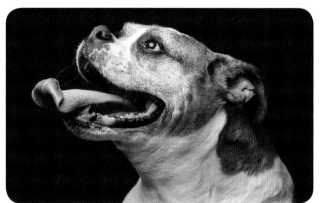
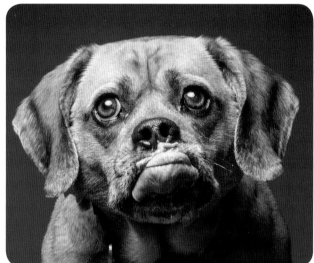
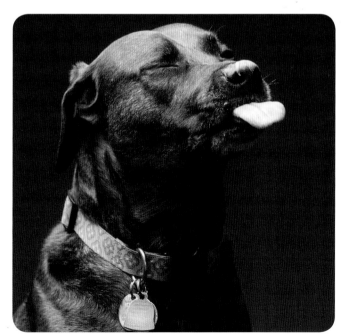
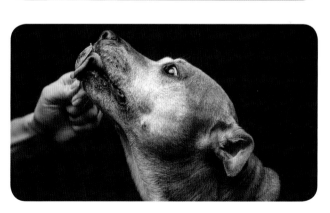

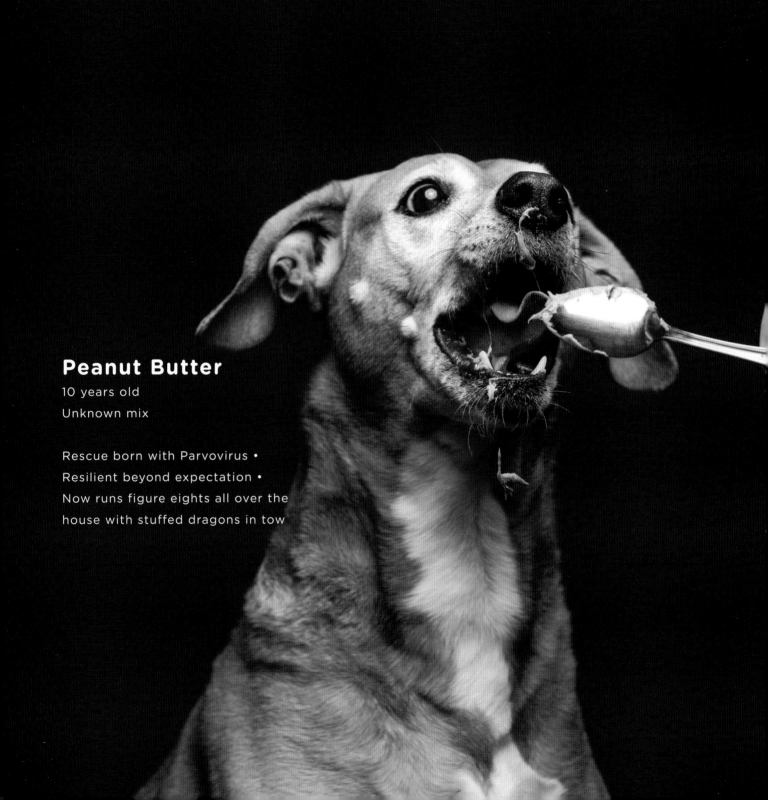

Peanut Butter

10 years old
Unknown mix

Rescue born with Parvovirus •
Resilient beyond expectation •
Now runs figure eights all over the
house with stuffed dragons in tow

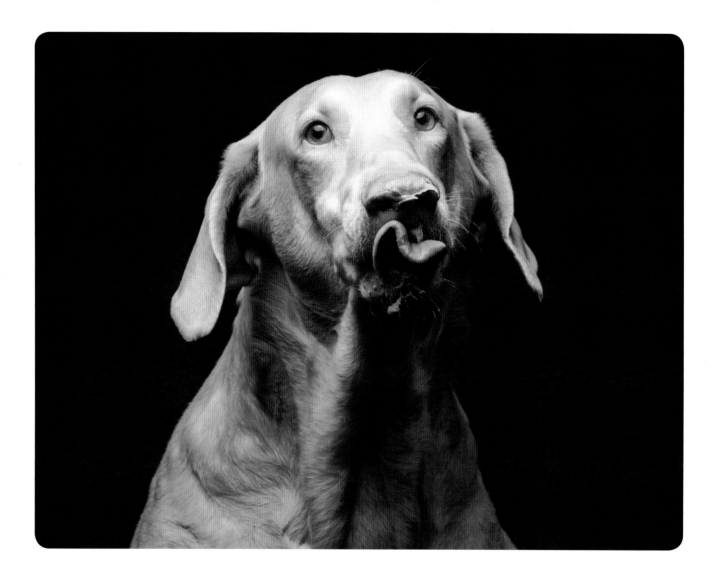

Buttermilk

7 years old
Doberman Pinscher

Rescue • A soft soul • Silly smile •
Sarcastic way of engaging play with
other dogs

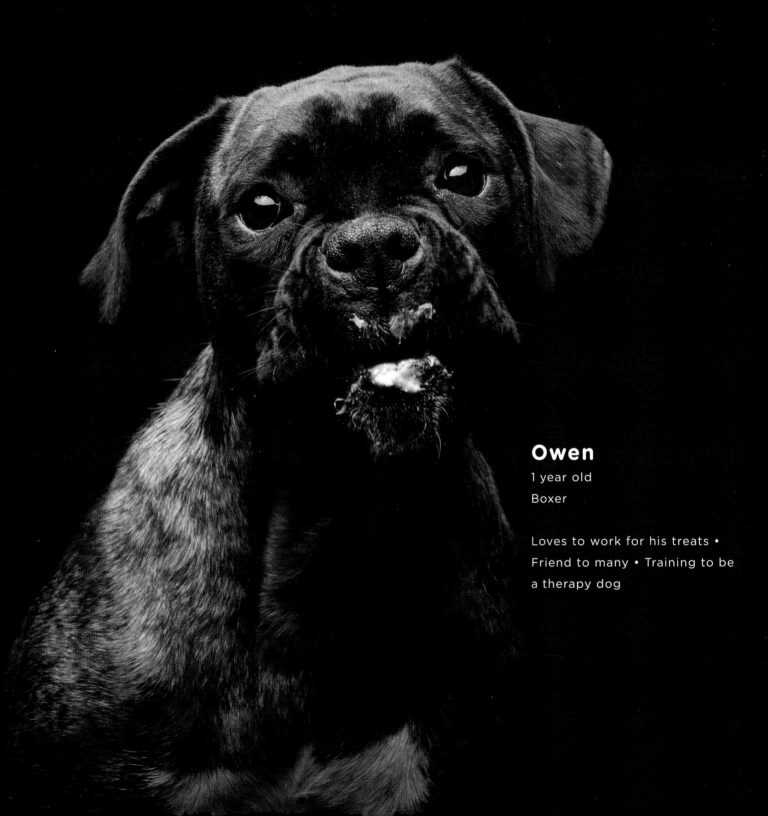

Owen

1 year old
Boxer

Loves to work for his treats •
Friend to many • Training to be
a therapy dog

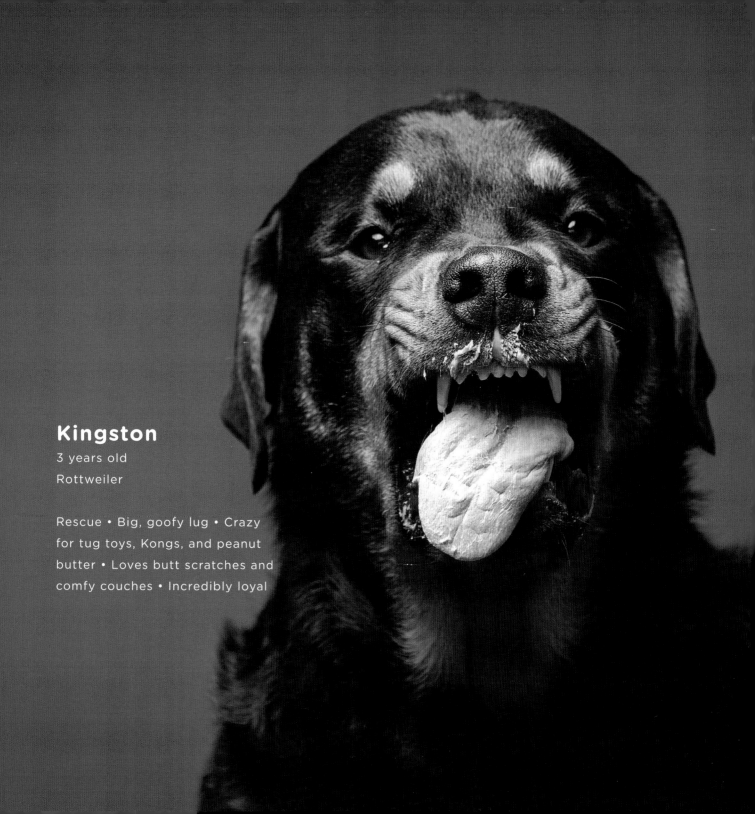

Kingston

3 years old
Rottweiler

Rescue • Big, goofy lug • Crazy
for tug toys, Kongs, and peanut
butter • Loves butt scratches and
comfy couches • Incredibly loyal

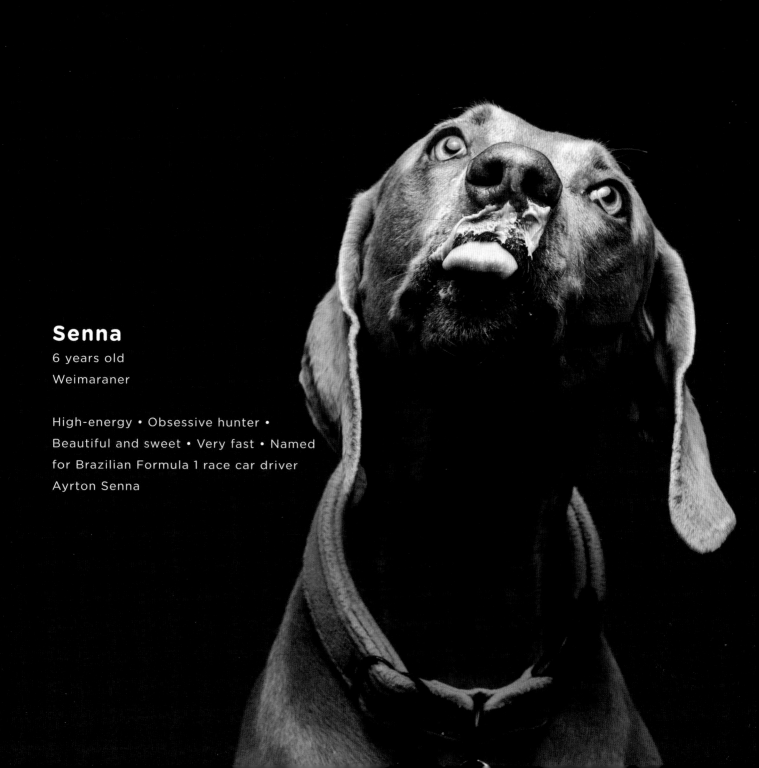

Senna

6 years old
Weimaraner

High-energy • Obsessive hunter •
Beautiful and sweet • Very fast • Named
for Brazilian Formula 1 race car driver
Ayrton Senna

Phoebe

11 years old
Chihuahua

Rescue • Loves burrowing beneath blankets •
Chases birds and butterflies • Named after, and
runs like, Phoebe Buffay from *Friends*

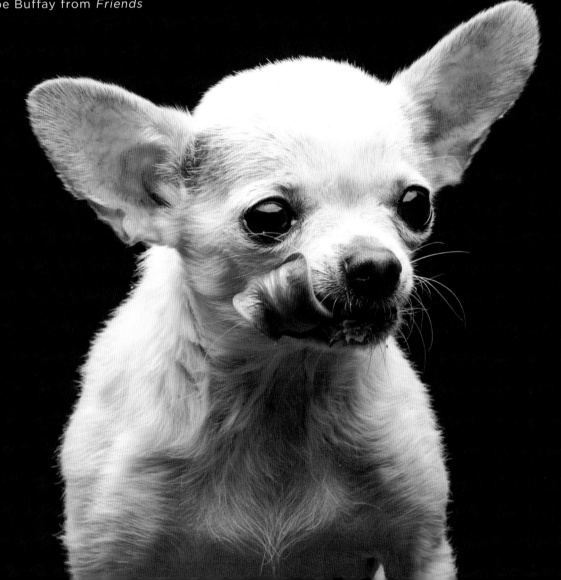

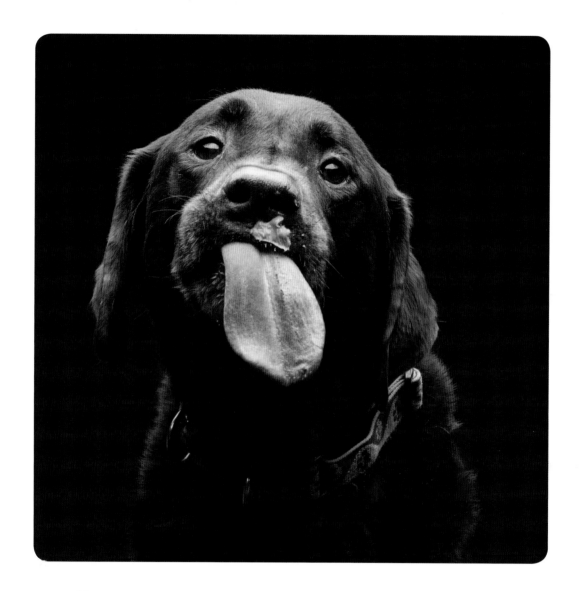

Bailey

13 years old

Chocolate Labrador Retriever

Loves to swim • Still plays a mean catch with his ball • Forever young

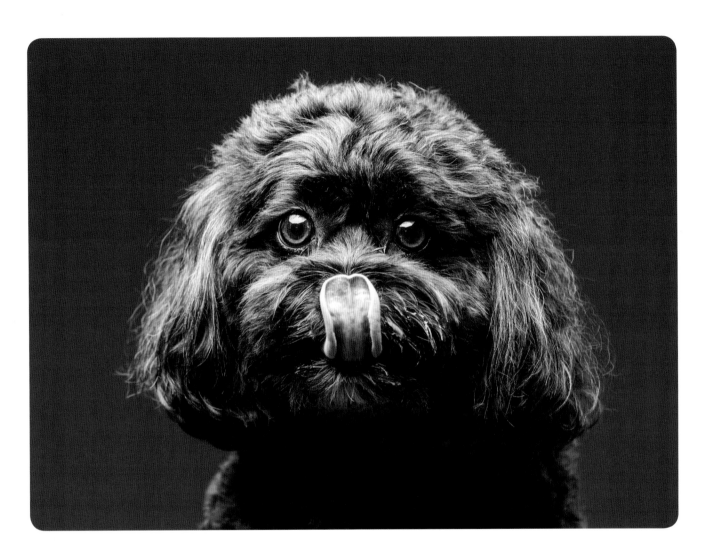

Gibby

6 years old
Cockapoo

The best tail feather around • Loves to snuggle and give kisses • Monitors the neighborhood from the patio door

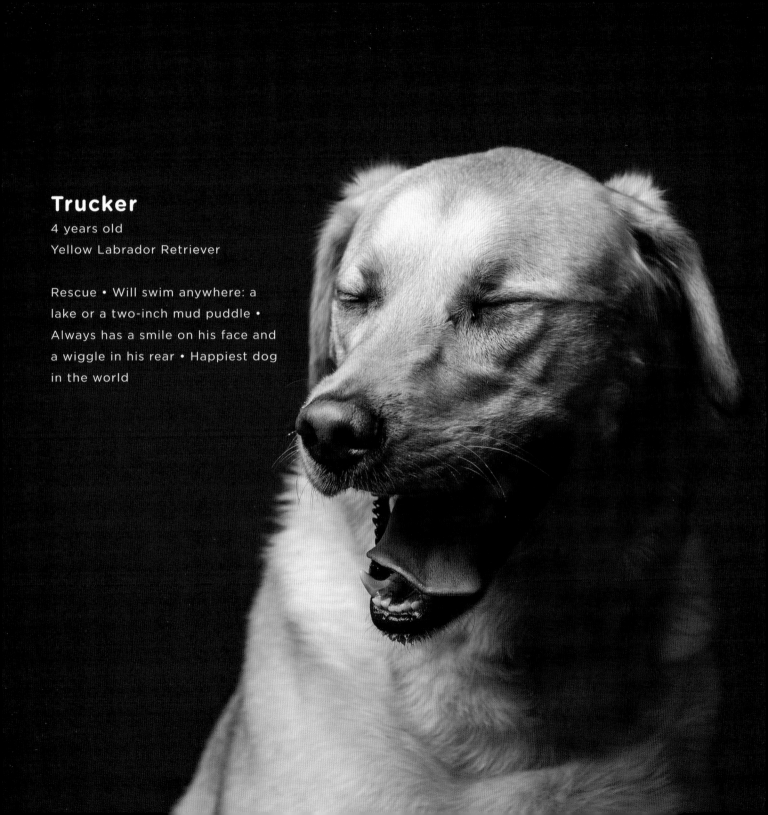

Trucker

4 years old
Yellow Labrador Retriever

Rescue • Will swim anywhere: a lake or a two-inch mud puddle • Always has a smile on his face and a wiggle in his rear • Happiest dog in the world

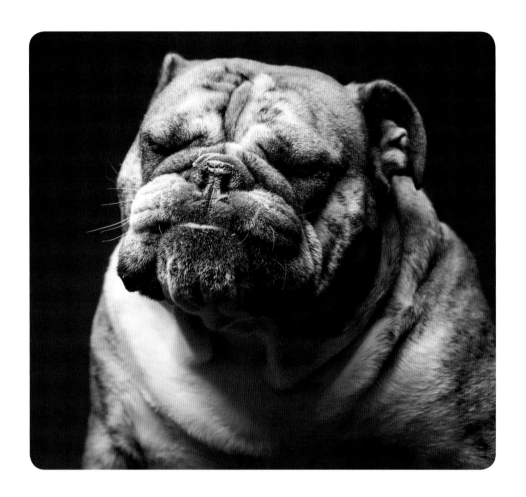

Gus

2 years old
English Bulldog

An English gentlemen • Loves
eating watermelon • Shakes
his butt when really excited,
causing his whole body to
shake • Makes pillow nests on
the couch to lay in for hours

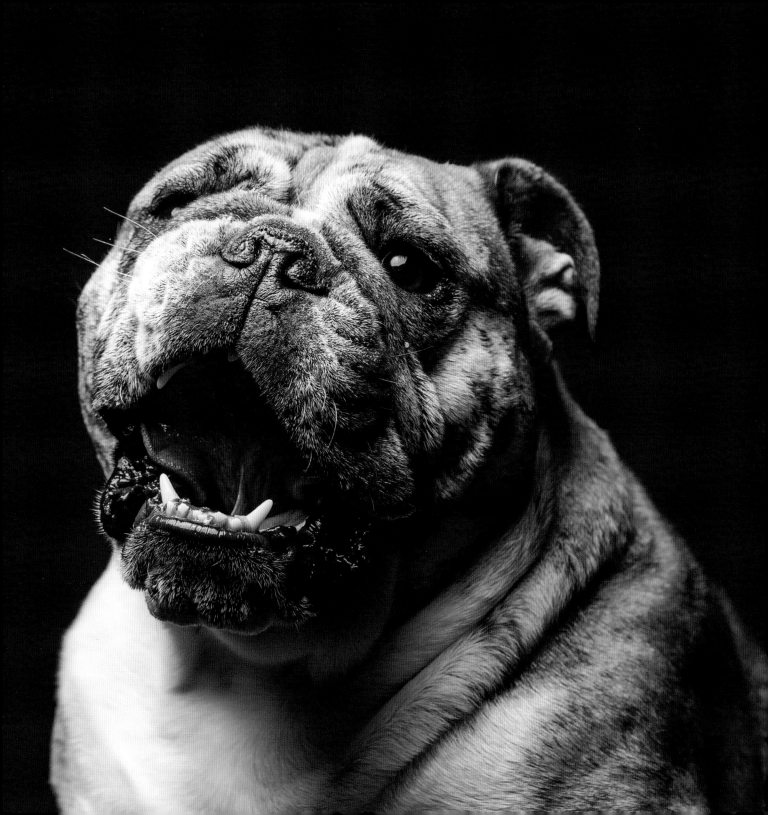

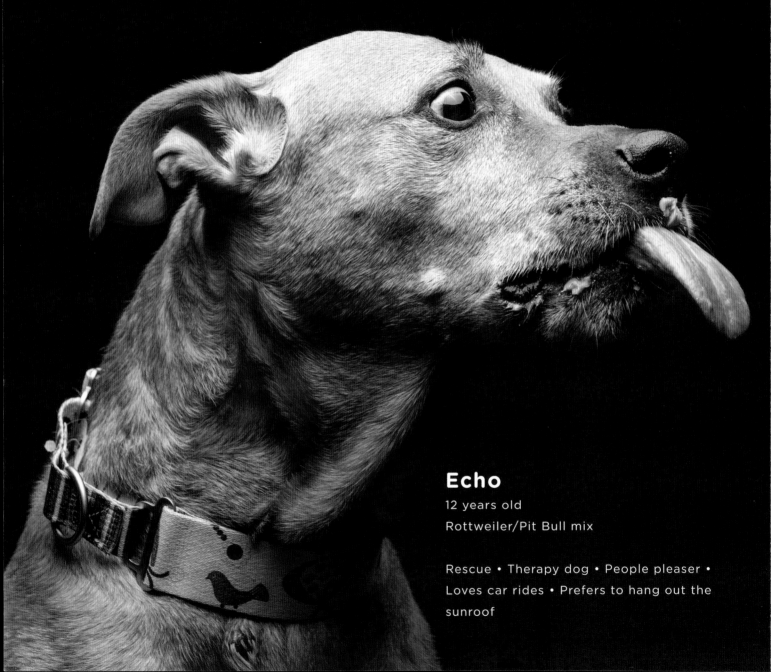

Echo

12 years old
Rottweiler/Pit Bull mix

Rescue • Therapy dog • People pleaser •
Loves car rides • Prefers to hang out the
sunroof

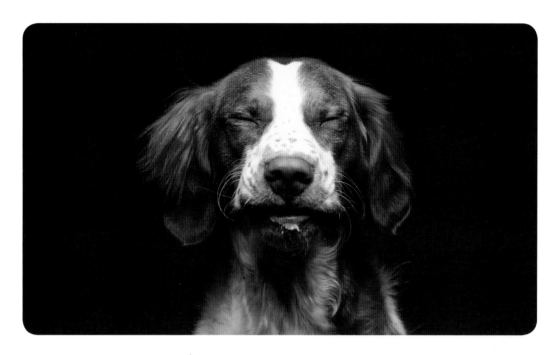

Bernie Kosar

1 year old
Brittany

Bad boy antics • Loves to swim • Chases birds, squirrels, and deer • A cuddler

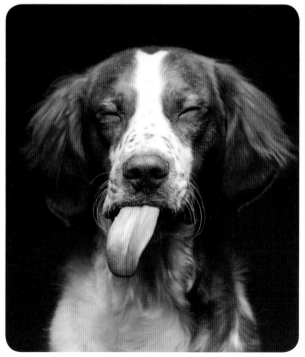

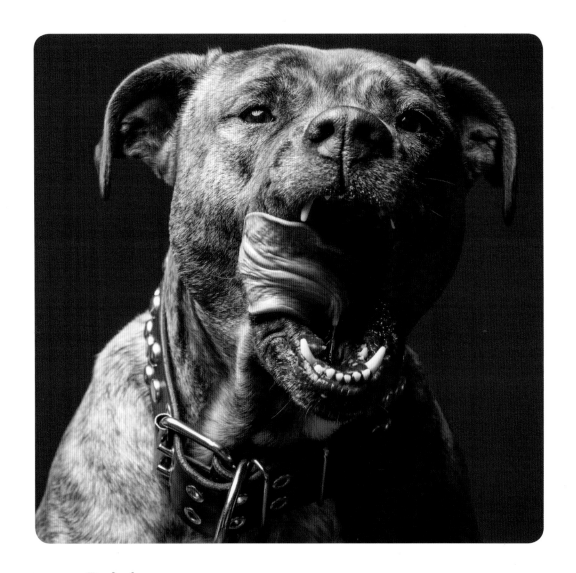

Brick

4 years old
Boxer/Pit Bull mix

Rescue • A lovable snuggle bug
• His family's first pit bull dog •
Certainly not their last

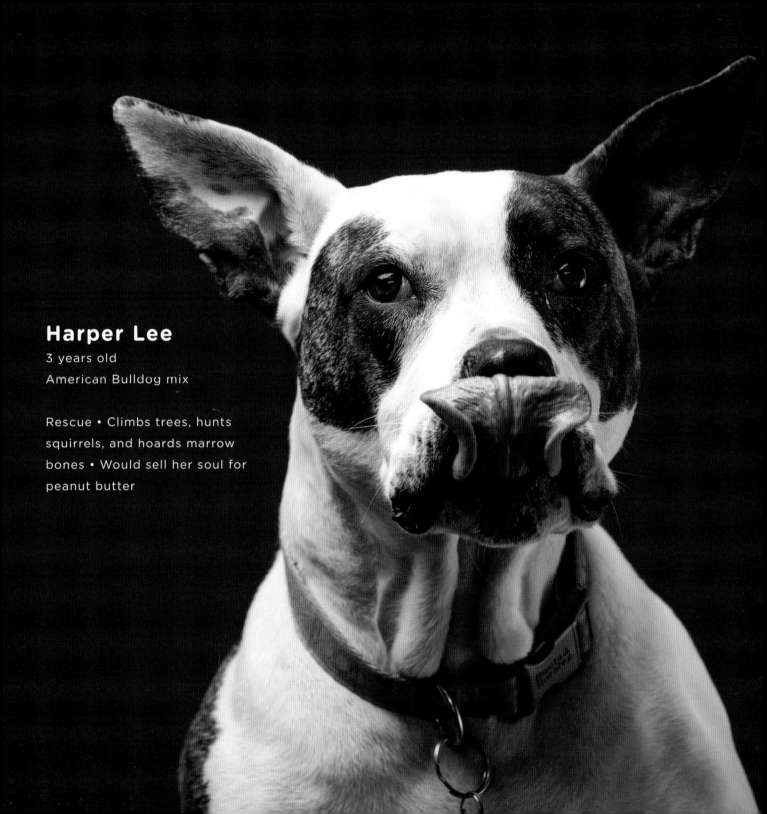

Harper Lee

3 years old
American Bulldog mix

Rescue • Climbs trees, hunts
squirrels, and hoards marrow
bones • Would sell her soul for
peanut butter

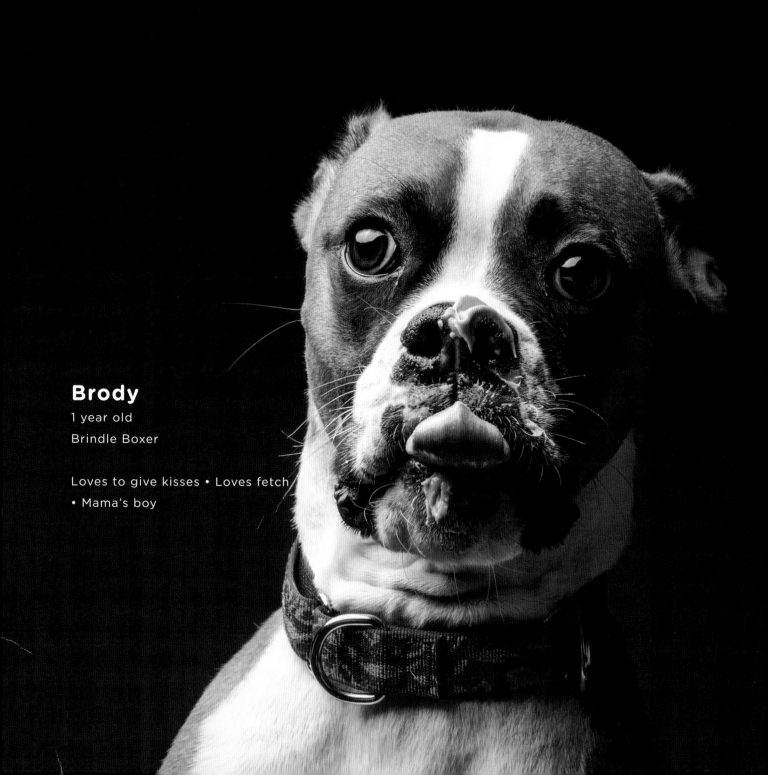

Brody
1 year old
Brindle Boxer

Loves to give kisses • Loves fetch
• Mama's boy

Jackson

8 years old
Puggle

Best cuddler ever • Loves
unconditionally • His human's
best friend

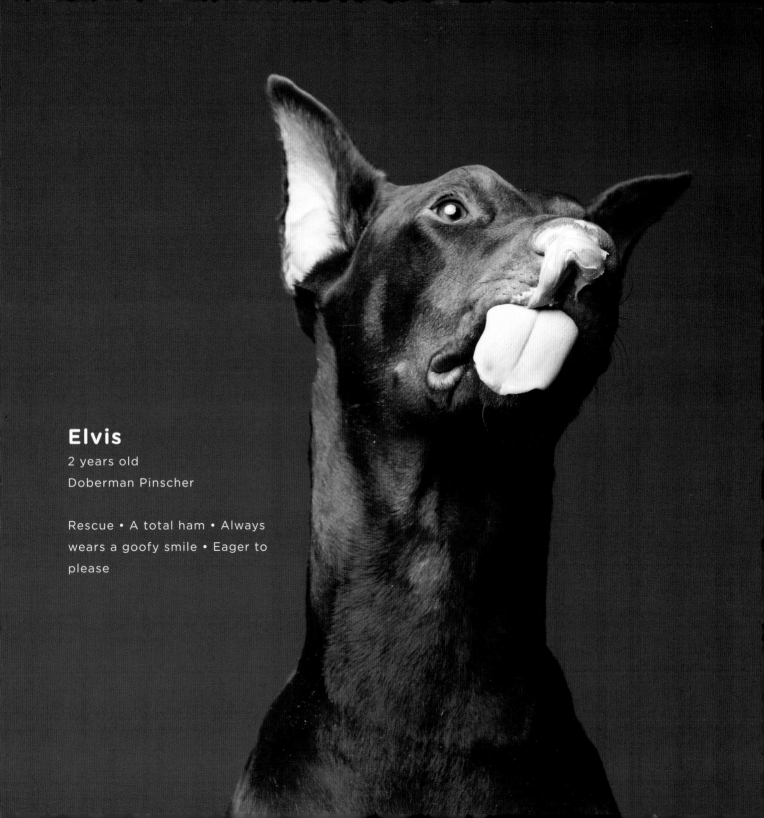

Elvis

2 years old
Doberman Pinscher

Rescue • A total ham • Always
wears a goofy smile • Eager to
please

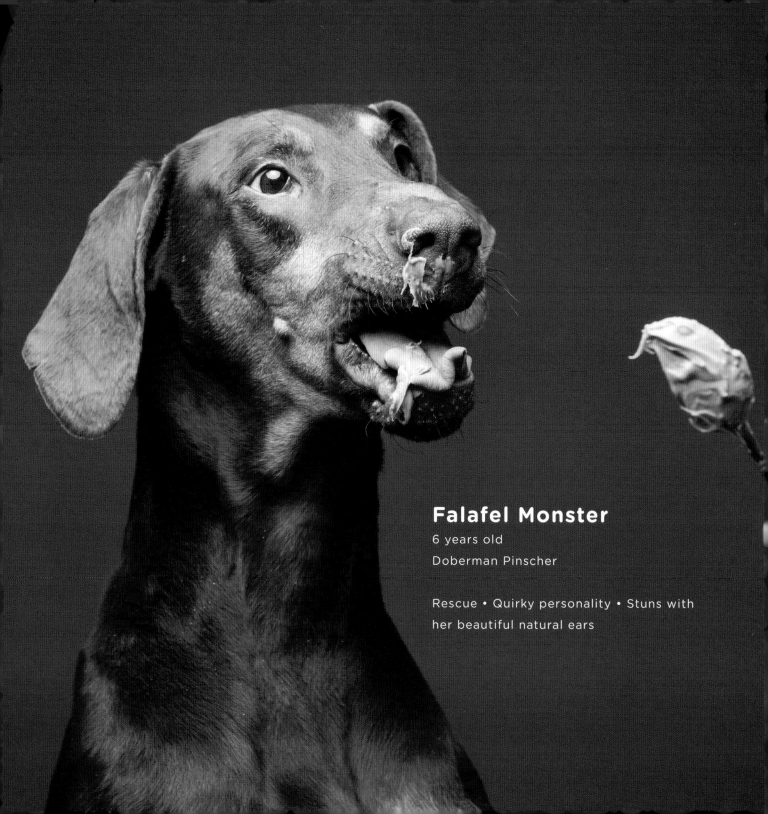

Falafel Monster

6 years old
Doberman Pinscher

Rescue • Quirky personality • Stuns with her beautiful natural ears

Onyx

10 weeks old
Boxer/German Shepherd/
Labrador Retriever mix

Rescue • Sweet and playful • Loves
going for walks • Enjoys playing
soccer with her Kong balls

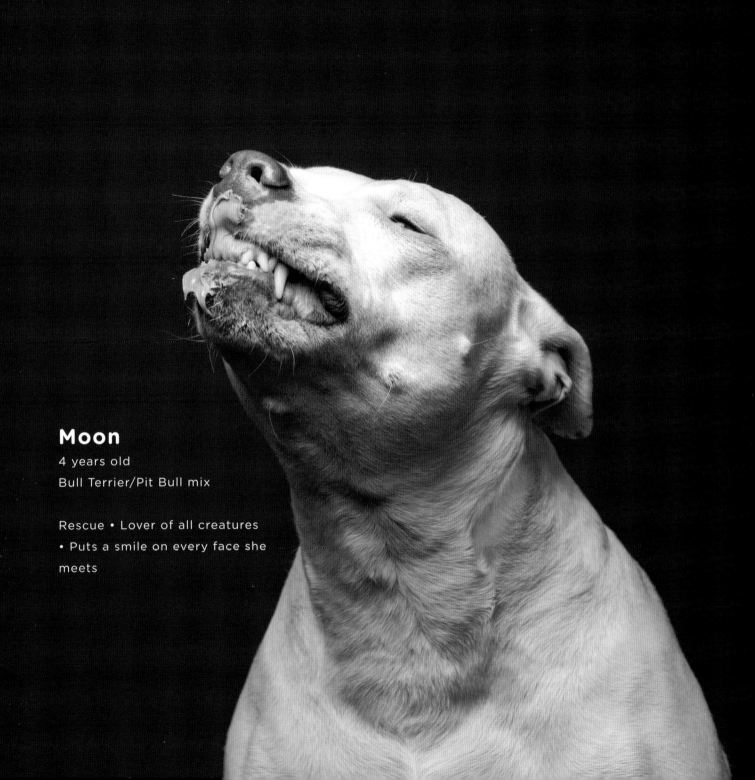

Moon

4 years old
Bull Terrier/Pit Bull mix

Rescue • Lover of all creatures
• Puts a smile on every face she
meets

Chance

10 years old
Unknown mix

Rescue • Happiest guy around • Tail wags a thousand miles per hour • Owner had always had large breed dogs with no interest in the little guys . . . until she met Chance

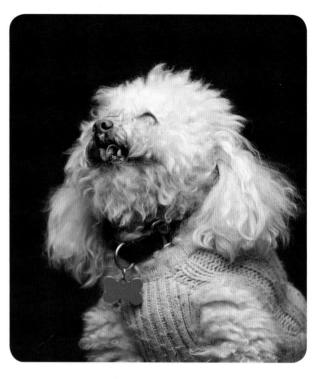

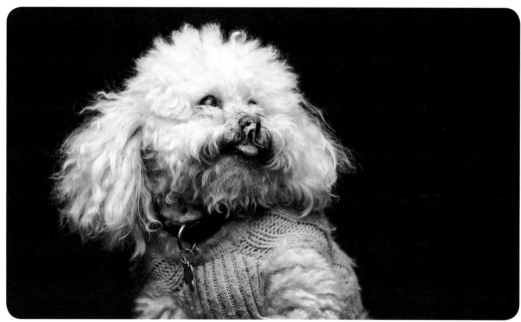

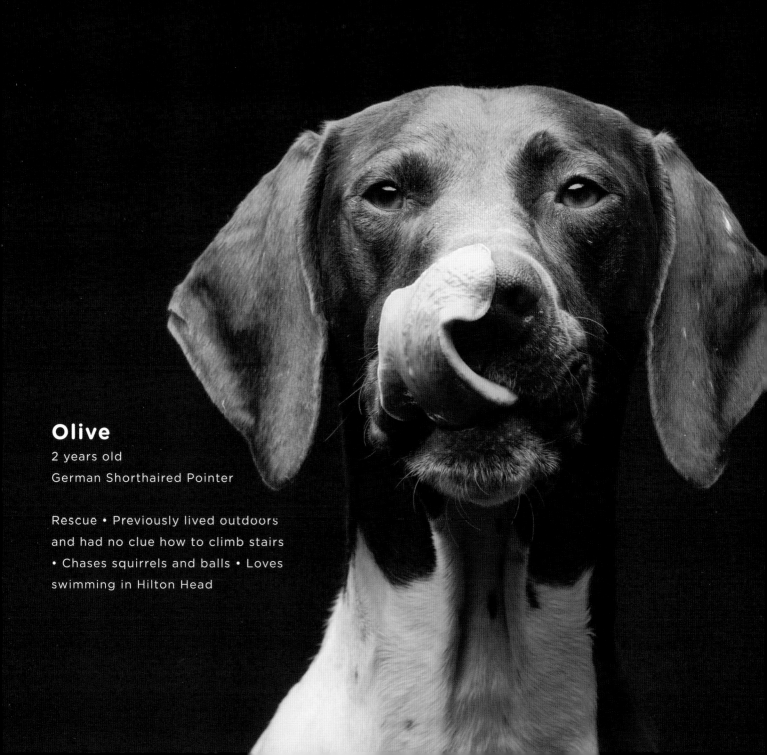

Olive
2 years old
German Shorthaired Pointer

Rescue • Previously lived outdoors
and had no clue how to climb stairs
• Chases squirrels and balls • Loves
swimming in Hilton Head

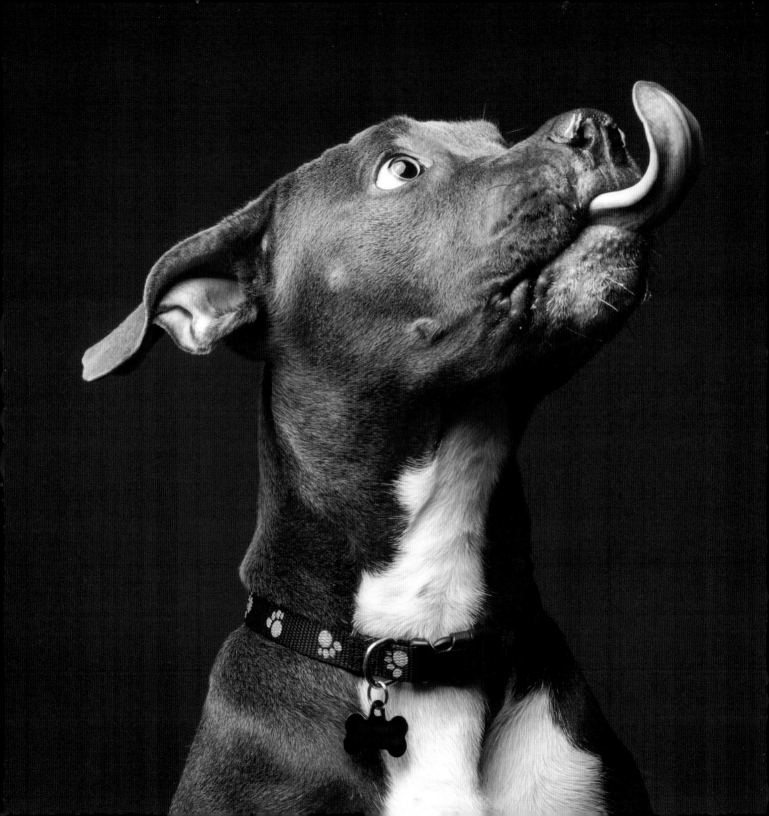

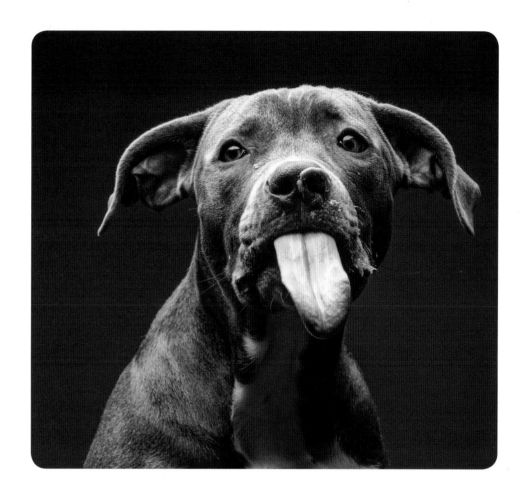

Bo

5 1/2 months old
American Bully

Unbridled enthusiasm for life
• Will play with anything that
squeaks—especially at midnight
• World's greatest kisser

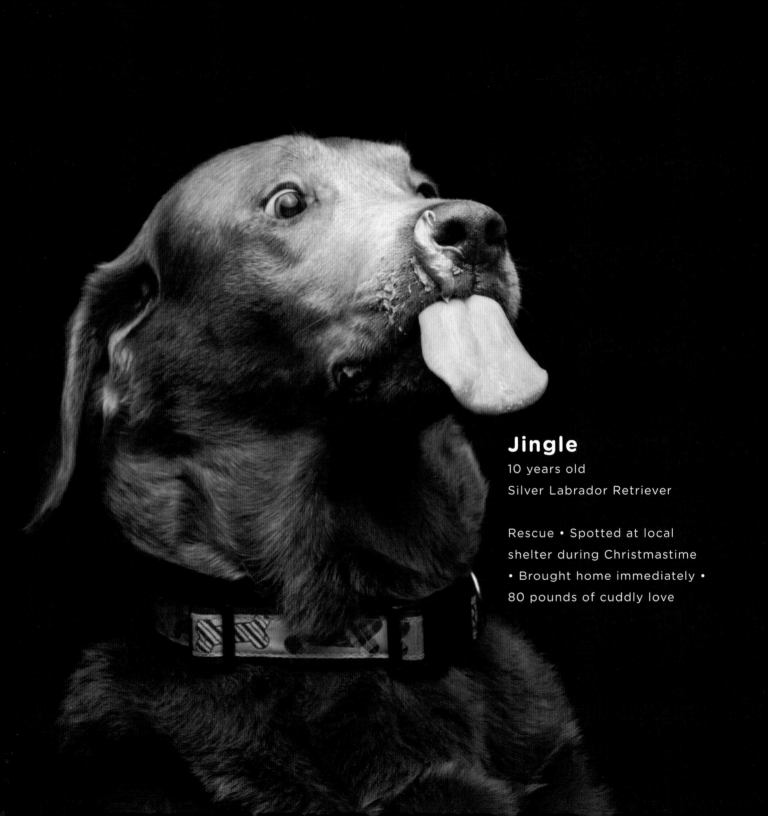

Jingle

10 years old
Silver Labrador Retriever

Rescue • Spotted at local
shelter during Christmastime
• Brought home immediately •
80 pounds of cuddly love

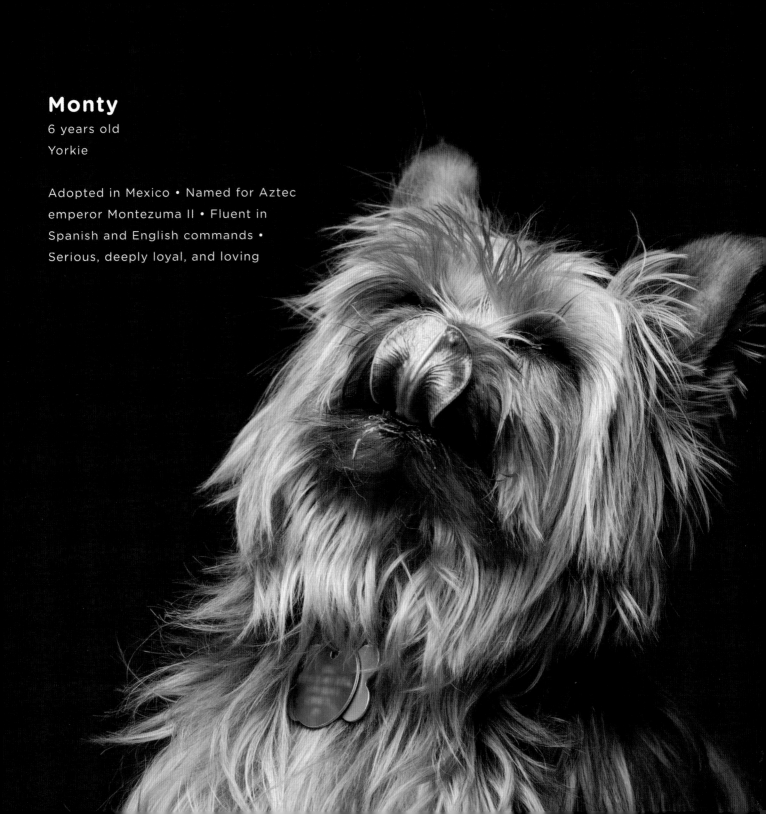

Monty

6 years old
Yorkie

Adopted in Mexico • Named for Aztec
emperor Montezuma II • Fluent in
Spanish and English commands •
Serious, deeply loyal, and loving

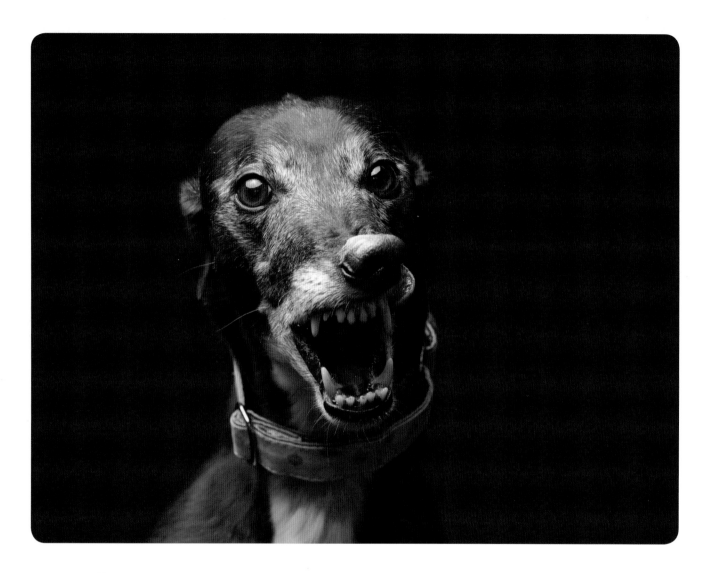

Gus

8 years old
Greyhound

Retired racing dog • Ran 28 races •
True calling is snuggling • Intuitive
soul • His wish: his humans' command

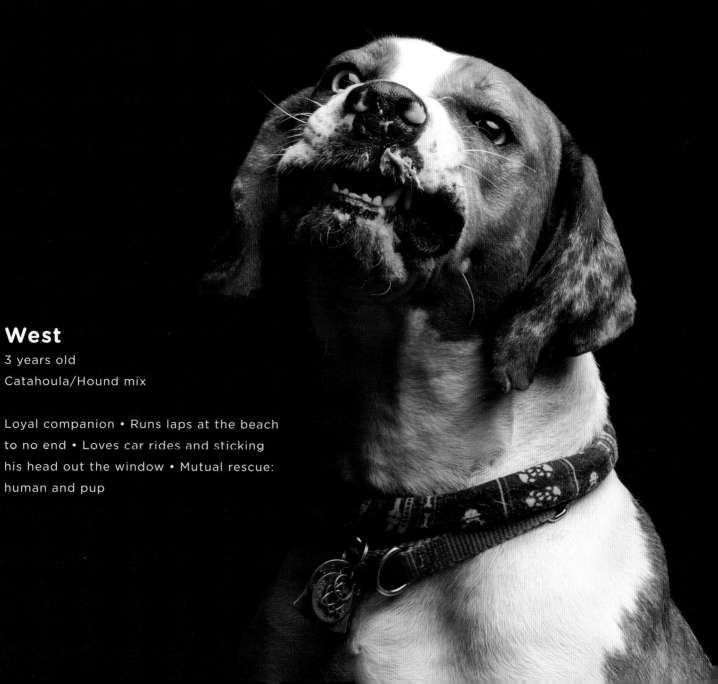

West

3 years old
Catahoula/Hound mix

Loyal companion • Runs laps at the beach
to no end • Loves car rides and sticking
his head out the window • Mutual rescue:
human and pup

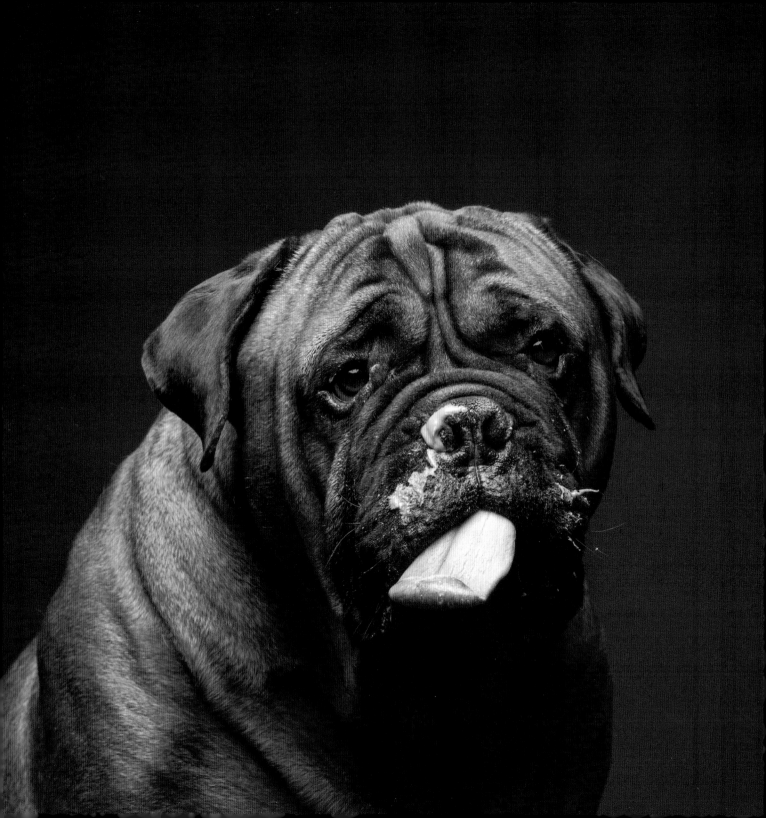

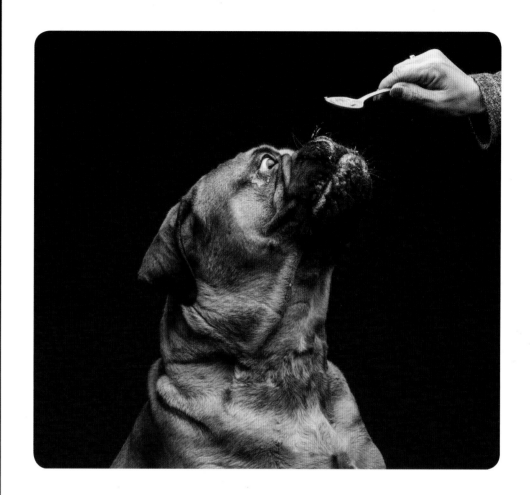

Reaper

5 years old

Bullmastiff

Clover

1 year old

Bullmastiff

Siblings • Give smushy face hugs • Irresistible kisses

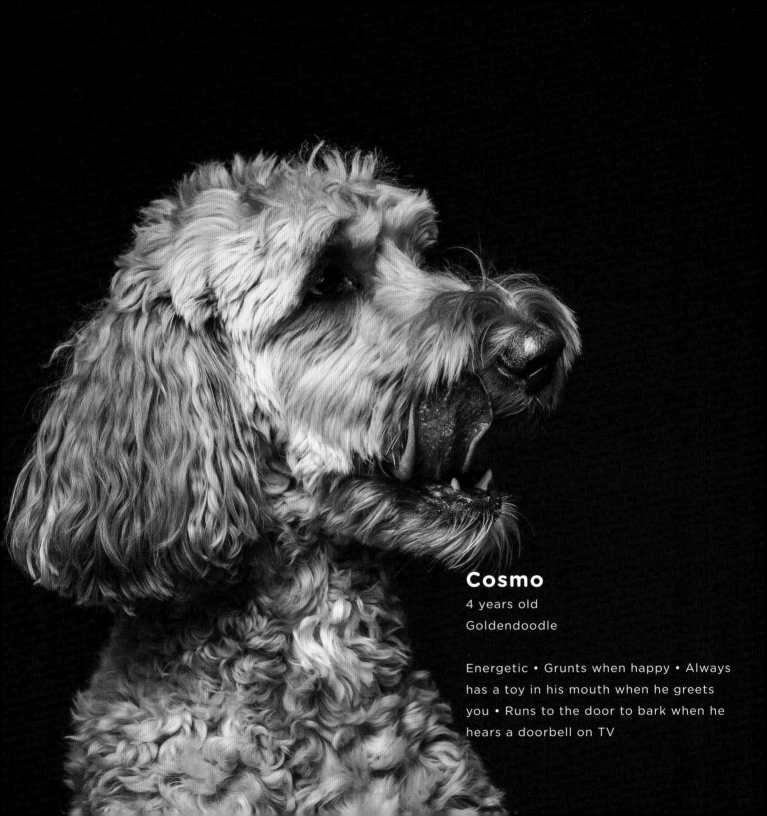

Cosmo

4 years old
Goldendoodle

Energetic • Grunts when happy • Always
has a toy in his mouth when he greets
you • Runs to the door to bark when he
hears a doorbell on TV

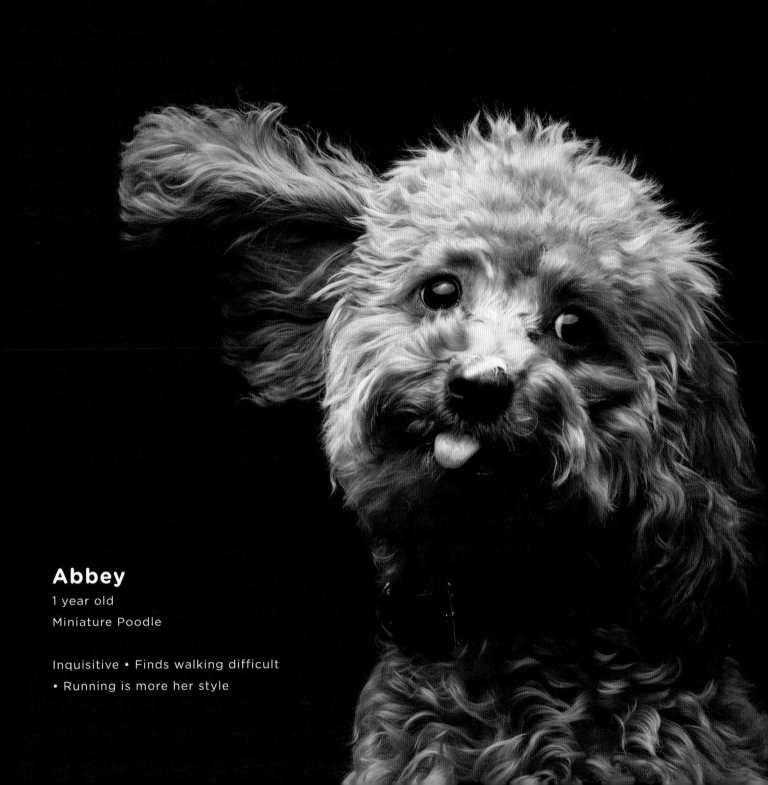

Abbey

1 year old
Miniature Poodle

Inquisitive • Finds walking difficult
• Running is more her style

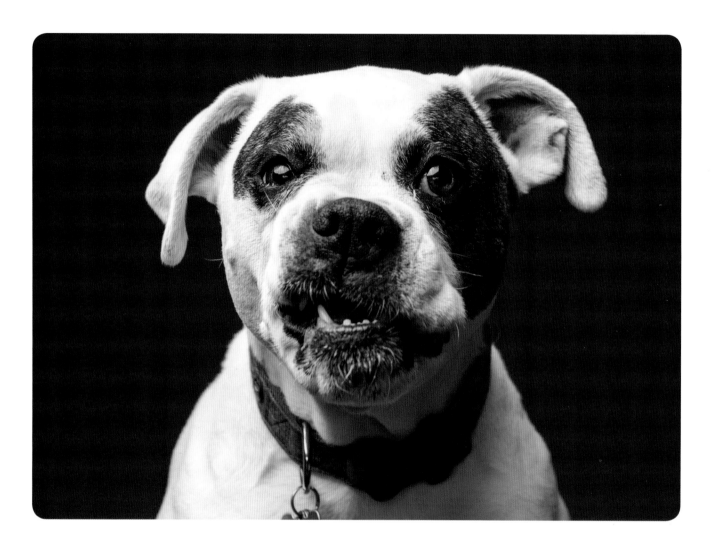

Roo

9 years old
Boxer

Enjoys neck rubs and trips to the beach • Mama's boy • Prefers leisure over strenuous activities • Will dress up and stand still for silly photos

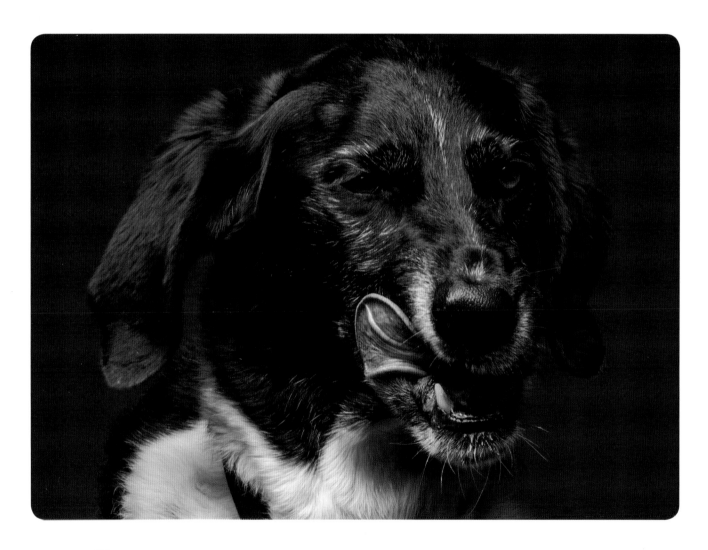

Dawson

10 years old

Pointer mix

Awesome Dawson • At times silly,
at times so dignified • Acts like he's
tough • Big ol' mush ball

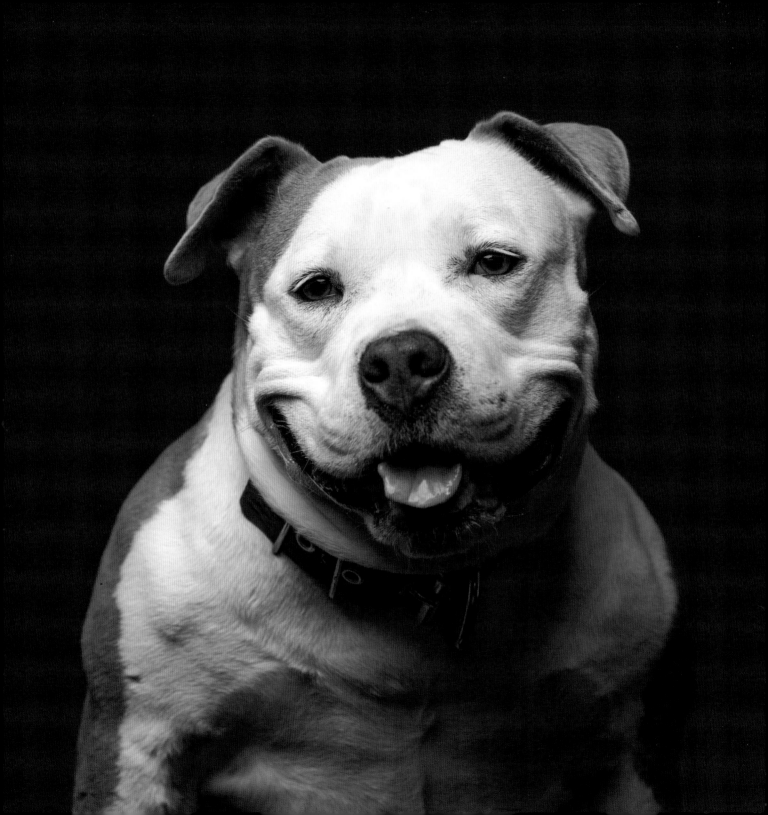

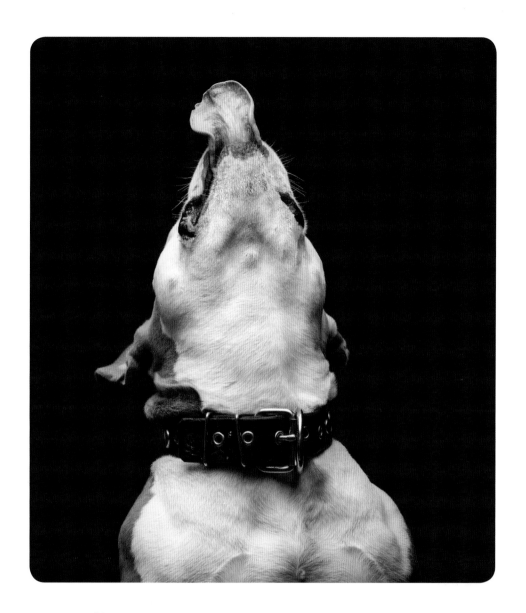

Stella

4 years old
English Bulldog/Pit Bull mix

Rescue • Her family's
diamond in the rough •
Lovingly referred to as a
baby hippo

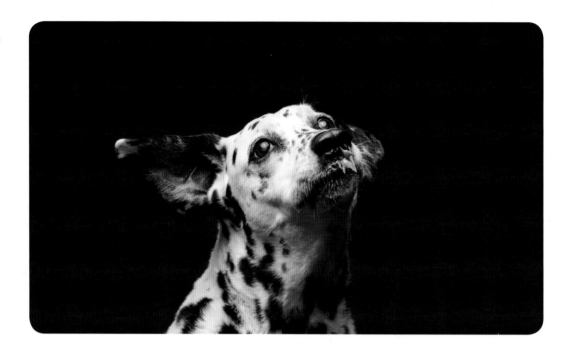

DeeDee

9 years old
Dalmatian

Loves eating human food • Enjoys
car rides and visits to the beach
• Will play fetch in the water until
her humans make her stop

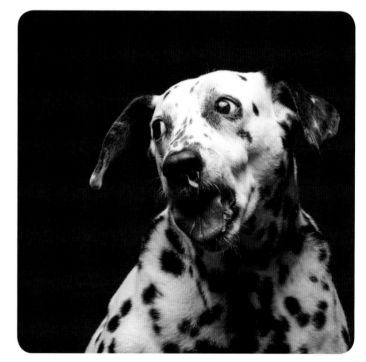

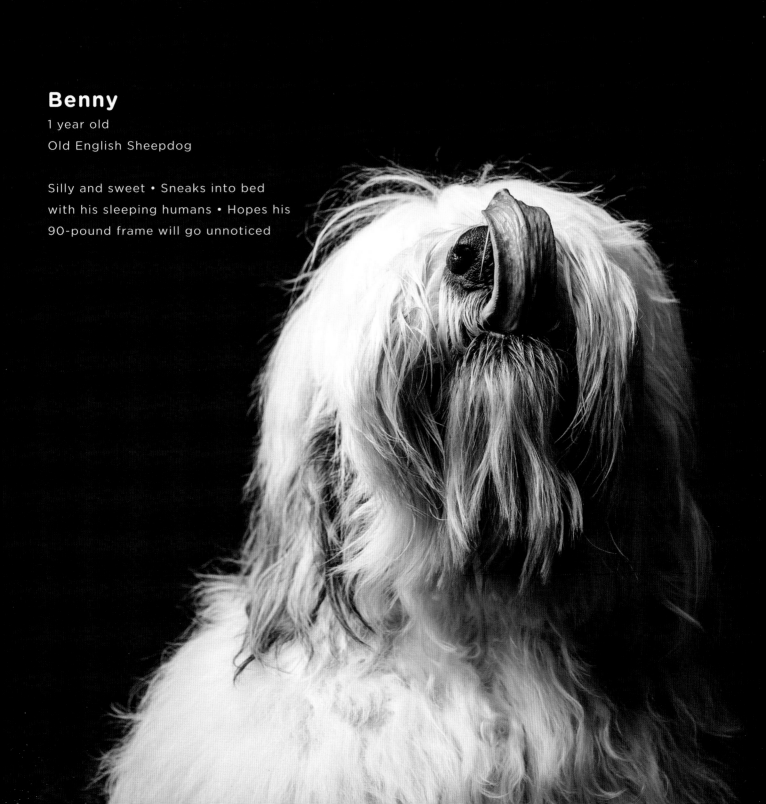

Benny

1 year old
Old English Sheepdog

Silly and sweet • Sneaks into bed
with his sleeping humans • Hopes his
90-pound frame will go unnoticed

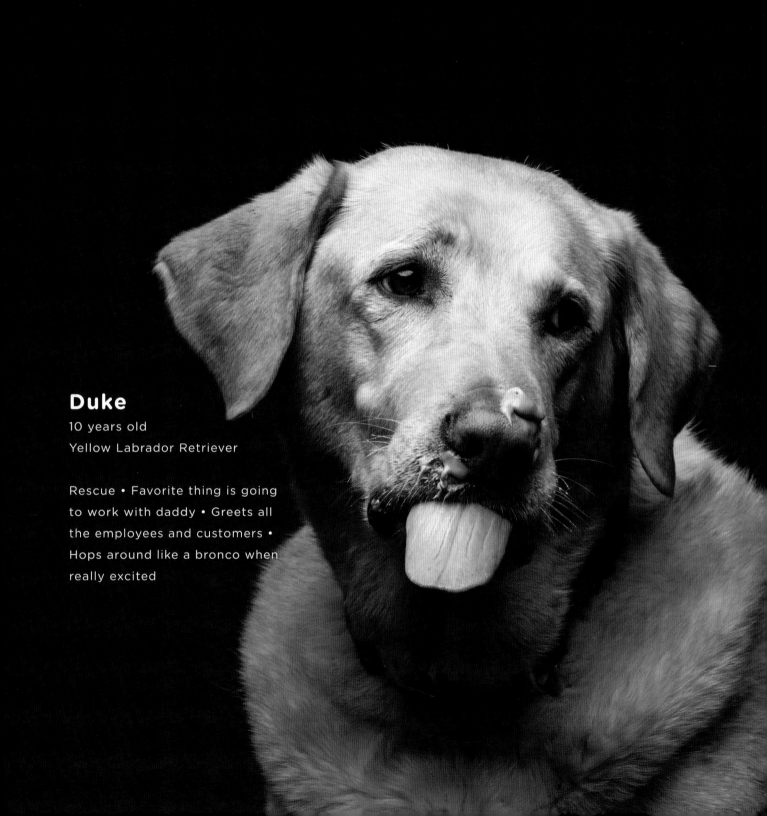

Duke
10 years old
Yellow Labrador Retriever

Rescue • Favorite thing is going
to work with daddy • Greets all
the employees and customers •
Hops around like a bronco when
really excited

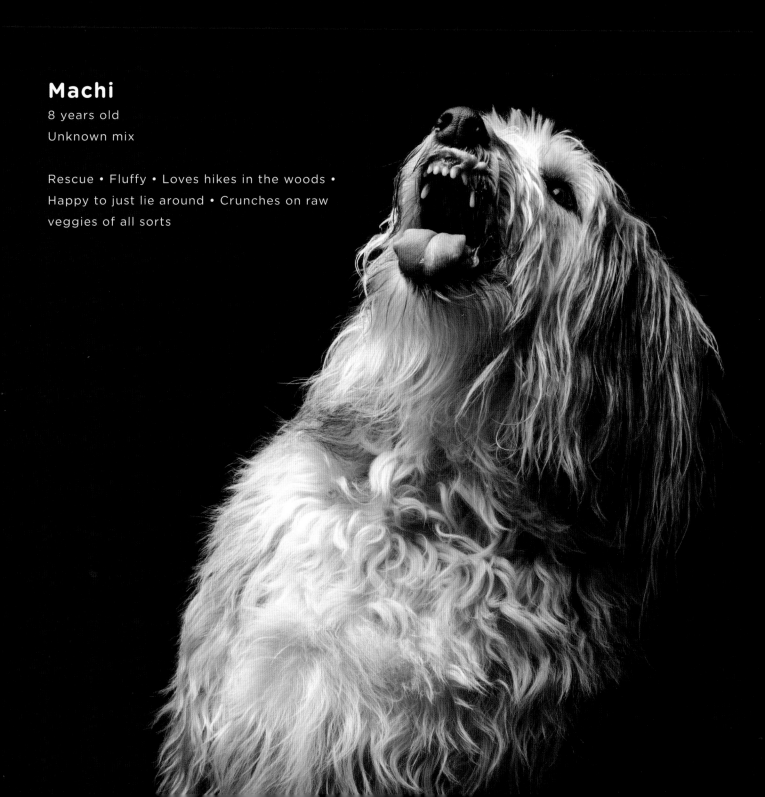

Machi

8 years old

Unknown mix

Rescue • Fluffy • Loves hikes in the woods •
Happy to just lie around • Crunches on raw
veggies of all sorts

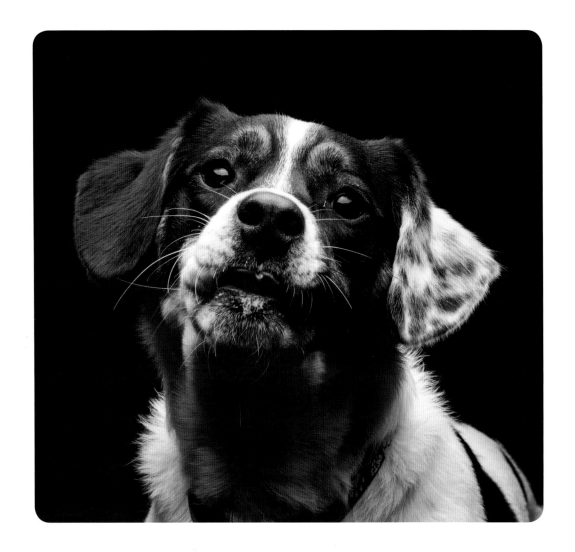

Flash

1 year old
Unknown mix

Rescue • As goofy as he looks •
Moves like a flash • Gets along with
everyone, including cats and horses •
Likes to play hard and live easy

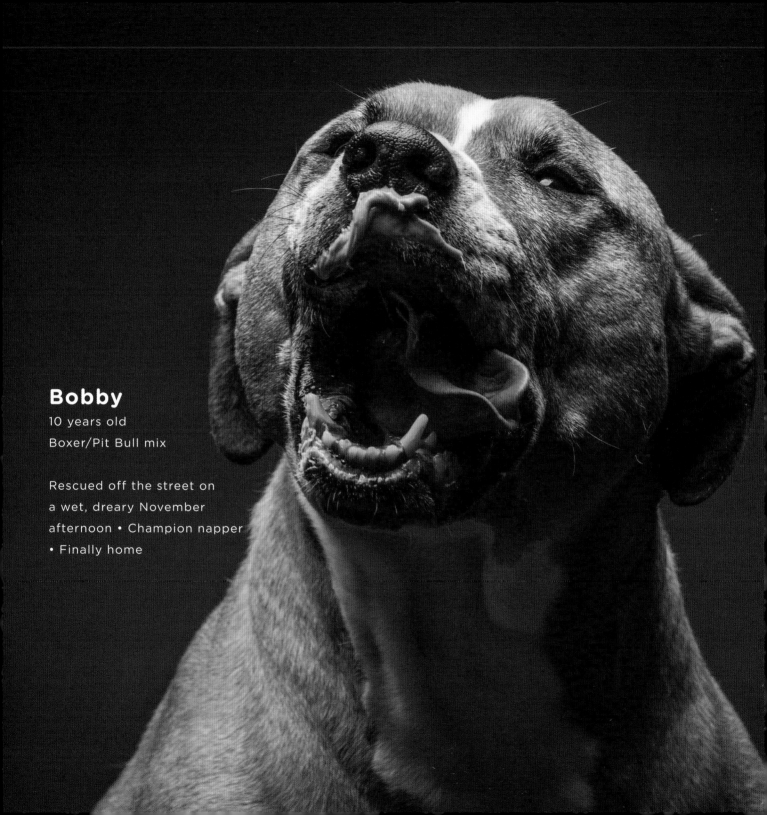

Bobby

10 years old
Boxer/Pit Bull mix

Rescued off the street on
a wet, dreary November
afternoon • Champion napper
• Finally home

Fozzie

2 years old
Goldendoodle

Playful • Loyal • Darn good
looking • Sleeps comfortably with
all four legs in the air, like he just
don't care

Smokey Joe

7 years old
Pit Bull/Great Dane mix

Rescue • Knucklehead • Will stare up a tree for an hour, willing squirrels to come down • Insists on sleeping under the covers, year round

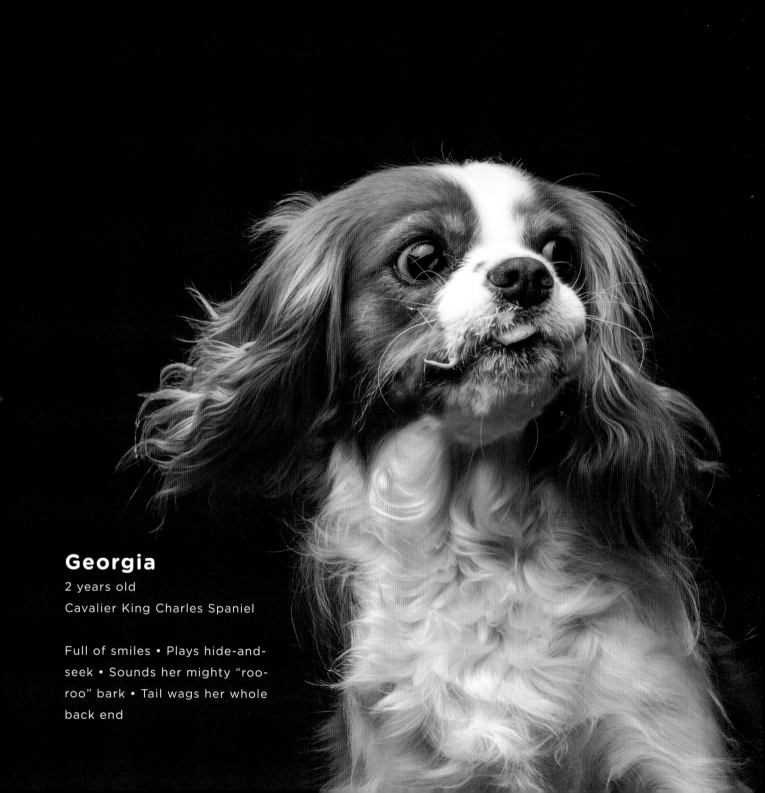

Georgia
2 years old
Cavalier King Charles Spaniel

Full of smiles • Plays hide-and-
seek • Sounds her mighty "roo-
roo" bark • Tail wags her whole
back end

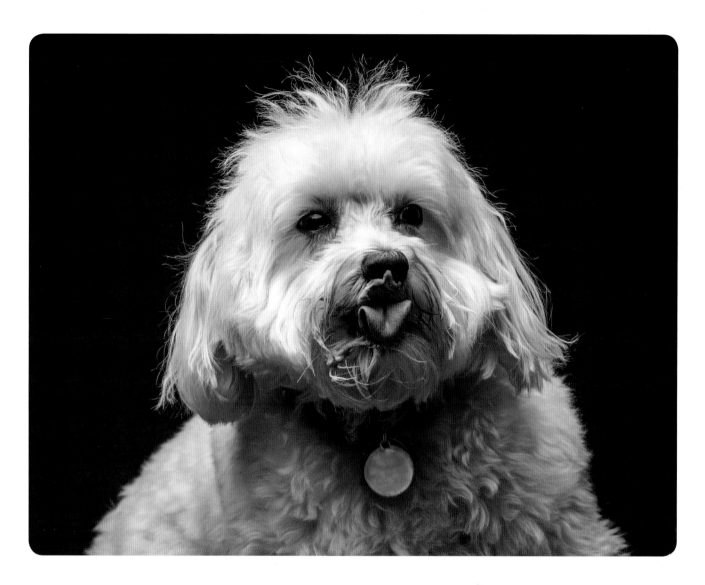

Lucy

1 year old

Havachon

Full of energy • Loves to be the center of attention • Nicknames: Sergeant Barky and Lucy Liu

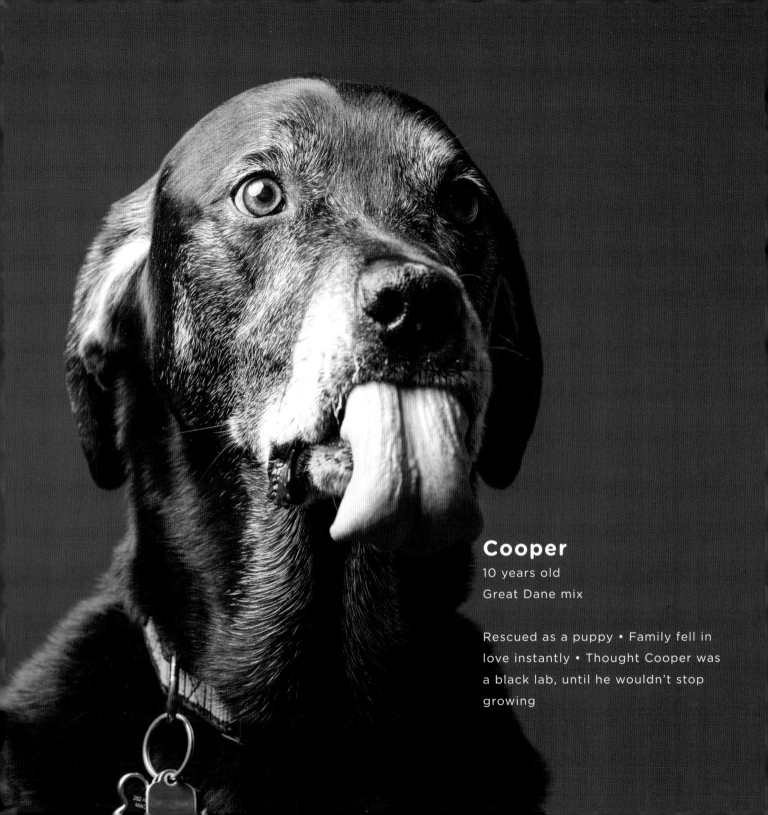

Cooper

10 years old
Great Dane mix

Rescued as a puppy • Family fell in
love instantly • Thought Cooper was
a black lab, until he wouldn't stop
growing

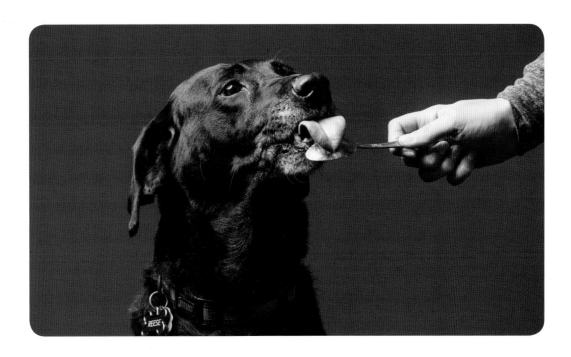

Reese

5 years old
Black Labrador Retriever mix

Rescue • Wonderful companion to her
brother, Cooper

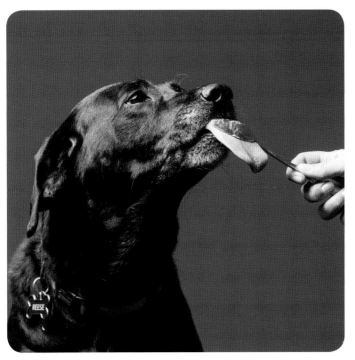

Frankie

3 years old
Yorkiepoo

Spirited little guy • 4 pounds • Loves
to bark at and chase much bigger
dogs • Maneuvers food bowl to
center of room with his paw and nose

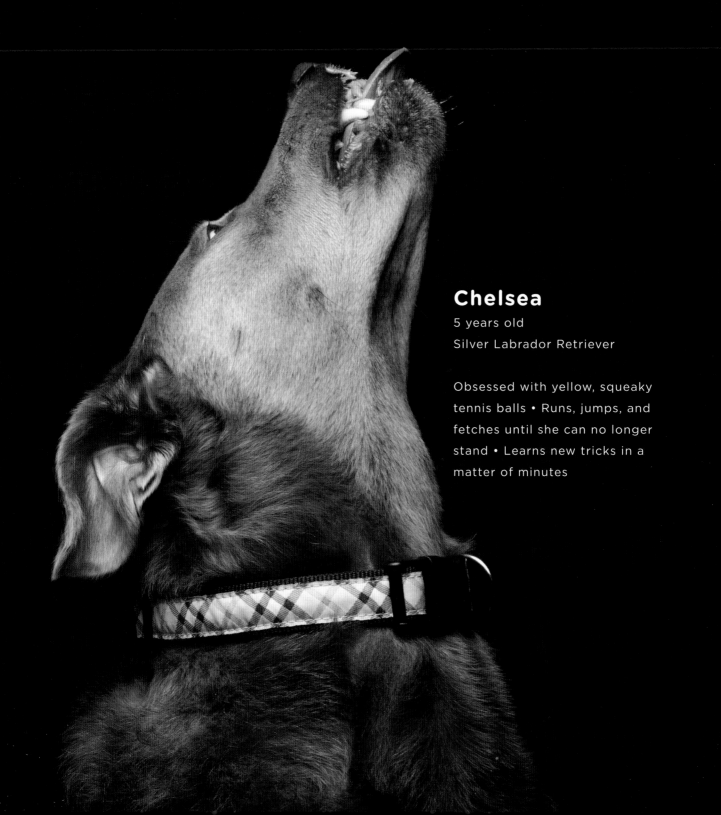

Chelsea

5 years old
Silver Labrador Retriever

Obsessed with yellow, squeaky tennis balls • Runs, jumps, and fetches until she can no longer stand • Learns new tricks in a matter of minutes

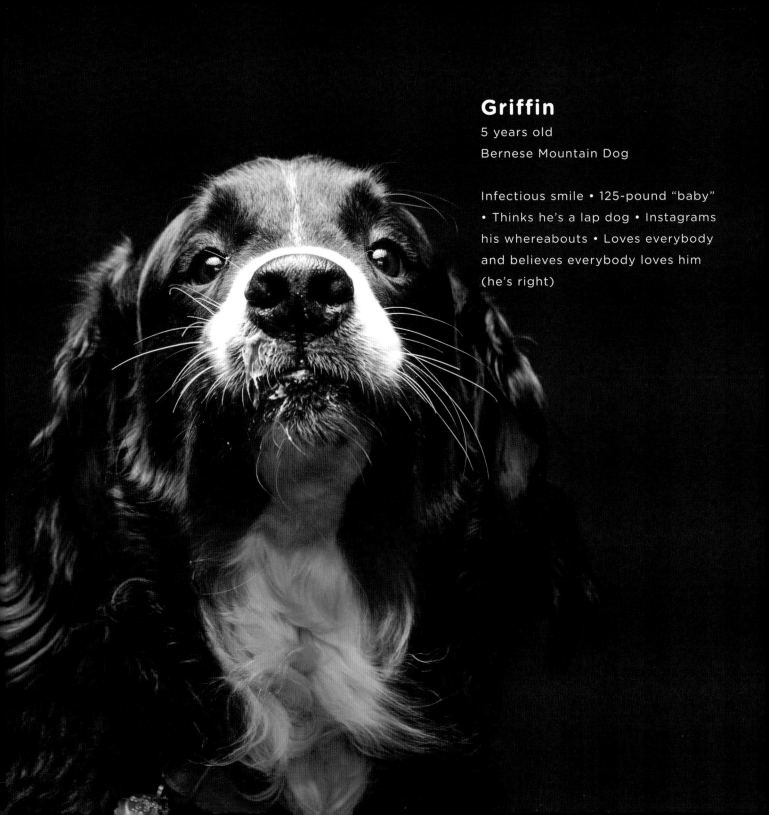

Griffin

5 years old
Bernese Mountain Dog

Infectious smile • 125-pound "baby"
• Thinks he's a lap dog • Instagrams
his whereabouts • Loves everybody
and believes everybody loves him
(he's right)

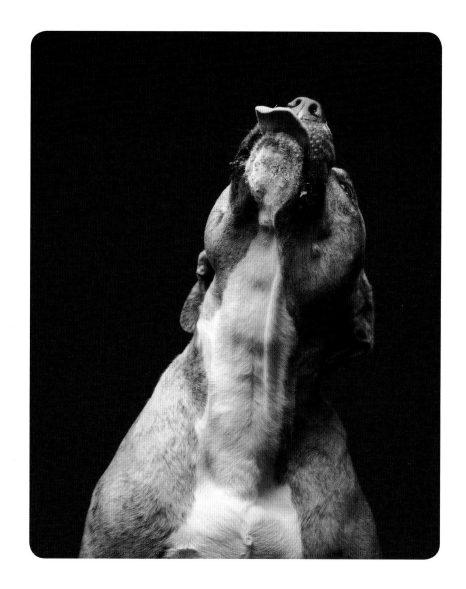

Eleanor

4 years old
Pit Bull

Rescue • Enjoys napping
• Licks faces obsessively •
Carries around sticks several
times her length

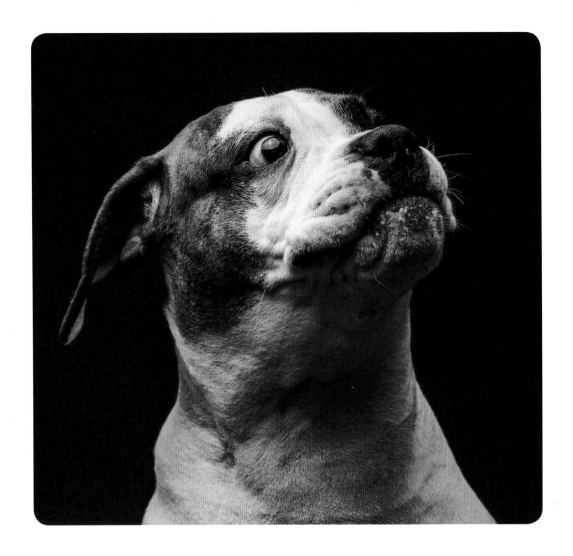

Coda

3 years old

Boxer

Energetic • Loves chasing balls in the
backyard • Loves taking naps on the
couch • Loves destroying squeak toys

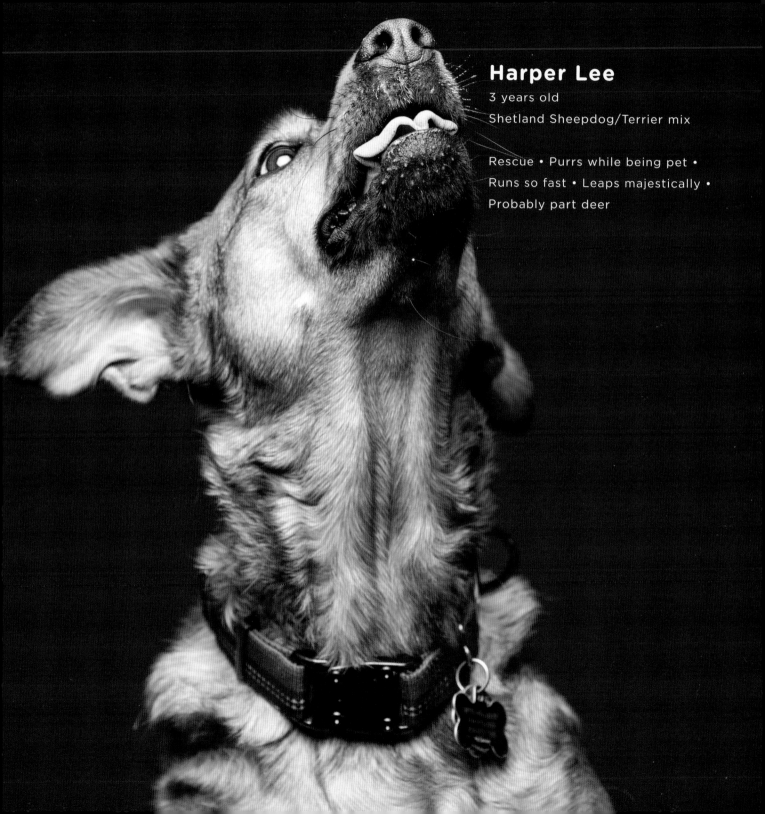

Harper Lee

3 years old

Shetland Sheepdog/Terrier mix

Rescue • Purrs while being pet •
Runs so fast • Leaps majestically •
Probably part deer

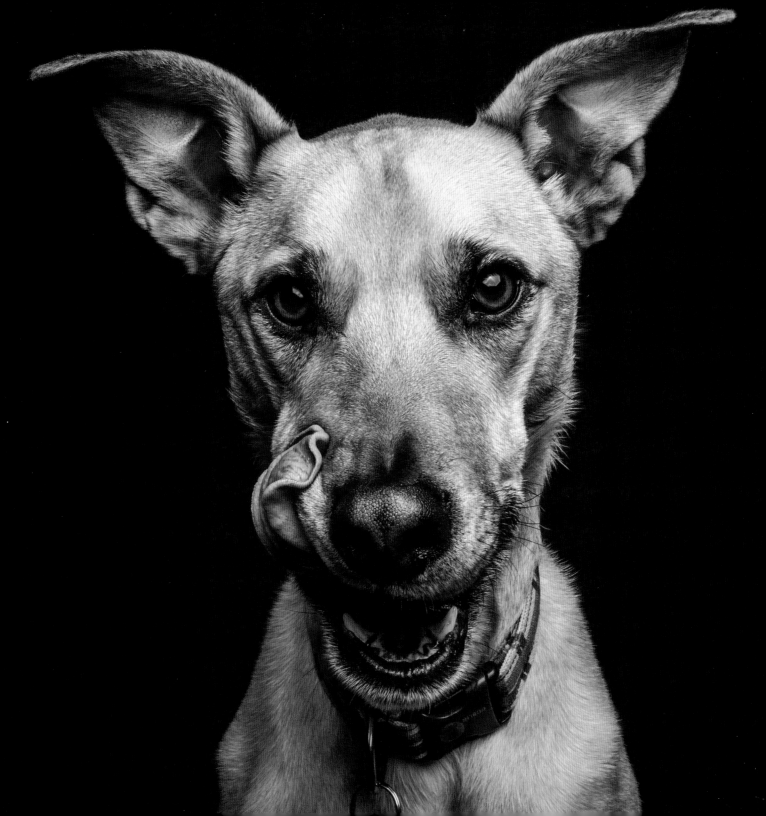

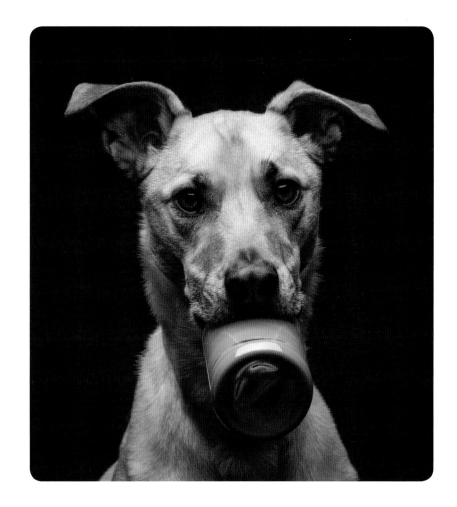

Leo

4 years old

German Shepherd/Greyhound mix

Rescue • Enjoys toy basket more than toys • Speed of a greyhound • Whips up dirt and grass running laps in backyard • A great snuggler • Brother to Kensie

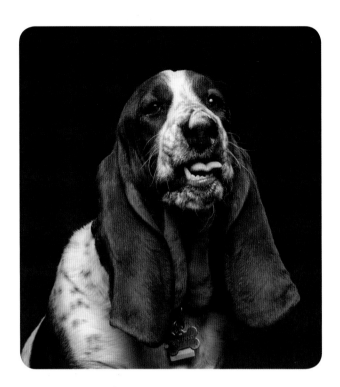

Huckleberry

1 year old
Basset Hound

Energetic • Trusting and loyal •
Best friends: Bob the Tortoiseshell
cat and Camilla the Labrador
Retriever mix • Large paws
equivalent to shovels • Dreams of
opening a landscaping company

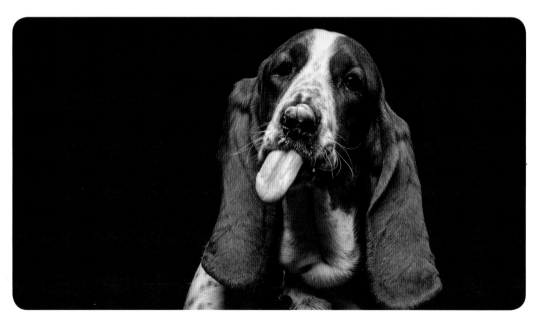

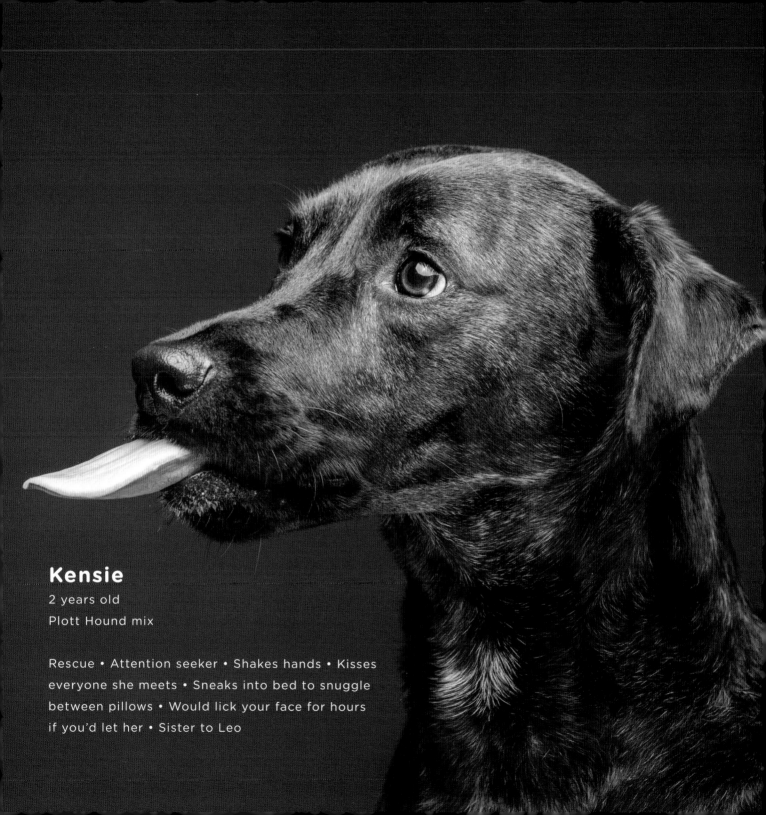

Kensie

2 years old
Plott Hound mix

Rescue • Attention seeker • Shakes hands • Kisses
everyone she meets • Sneaks into bed to snuggle
between pillows • Would lick your face for hours
if you'd let her • Sister to Leo

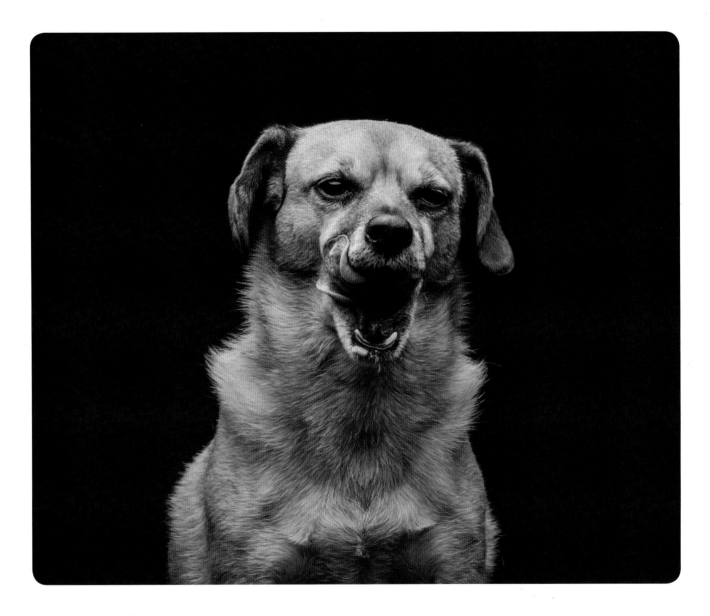

Sobe

6 years old

Pug/Beagle/Chihuahua mix

Rescue • Easy going • Loves people
• Not interested in other dogs

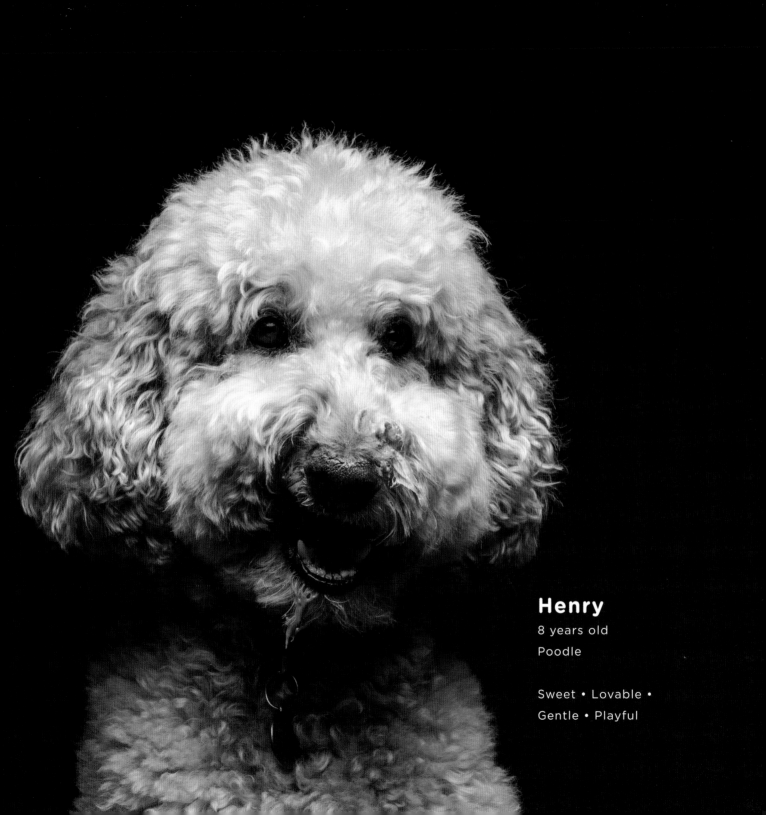

Henry

8 years old
Poodle

Sweet • Lovable •
Gentle • Playful

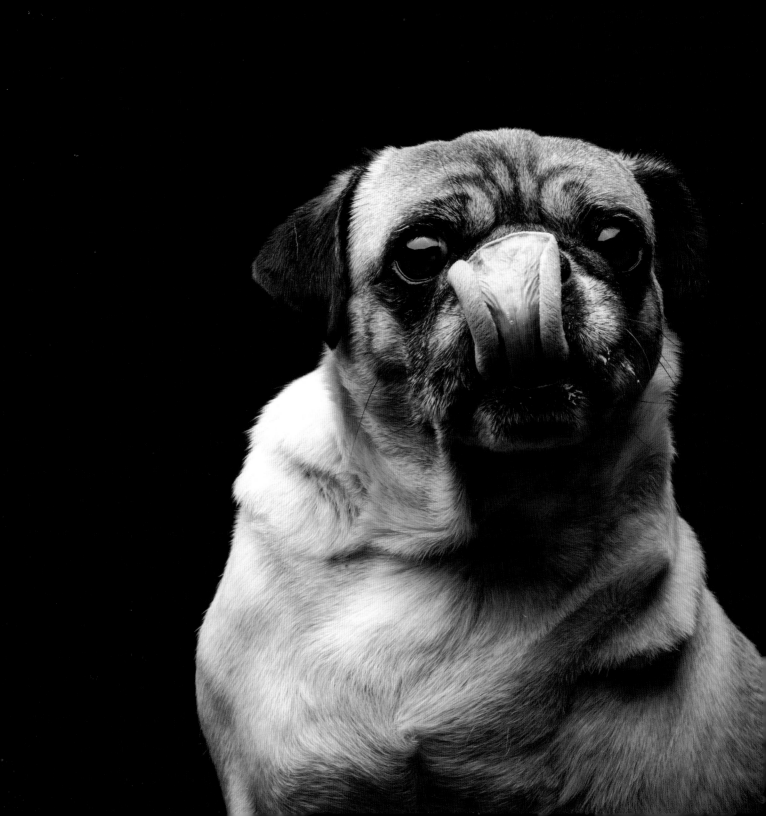

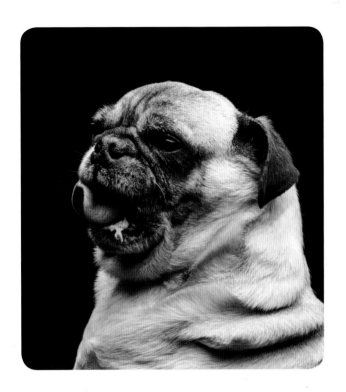

Goombah

8 years old
Pug

"Sings" alongside his human, throwing his
head back to howl • From sickness to health
• Four legs to three • Fostered to adopted •
Human's best decision yet

Hulkosaurus Rex (Hulk)

8 months old

Akita

Happy-go-lucky • Ensures no squirrels enter his property • Sleeps in front of his designated fan year round • Plays with anything that squeaks

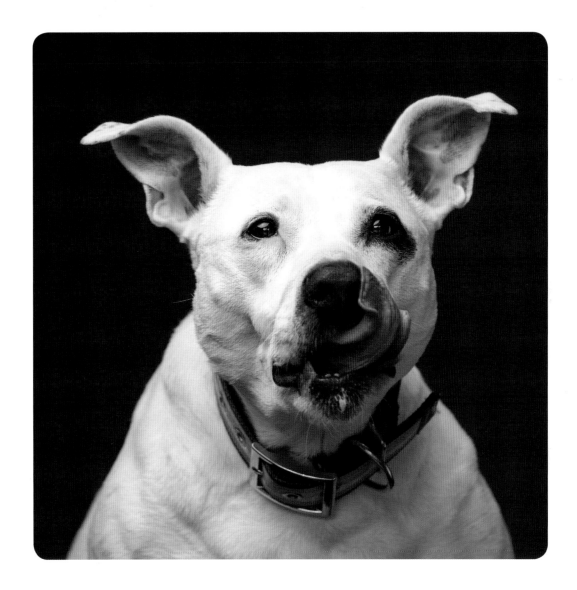

Inara

10 years old
American Pit Bull Terrier

Rescue • Acts like a goofy puppy • Wiggles and wags so hard she smacks herself in the face with her tail • Adores her cat brother, Malcolm

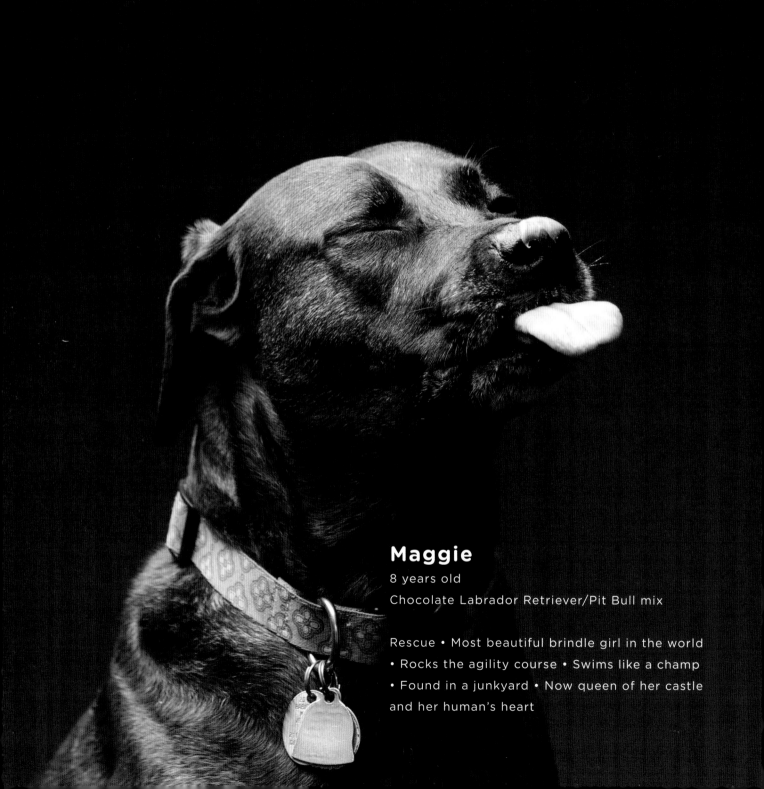

Maggie

8 years old

Chocolate Labrador Retriever/Pit Bull mix

Rescue • Most beautiful brindle girl in the world
• Rocks the agility course • Swims like a champ
• Found in a junkyard • Now queen of her castle
and her human's heart

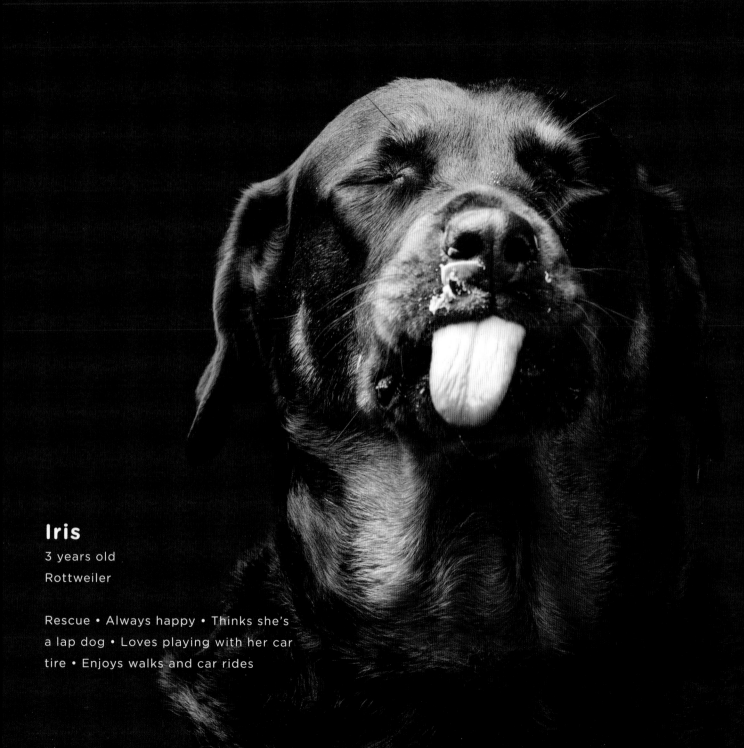

Iris

3 years old
Rottweiler

Rescue • Always happy • Thinks she's
a lap dog • Loves playing with her car
tire • Enjoys walks and car rides

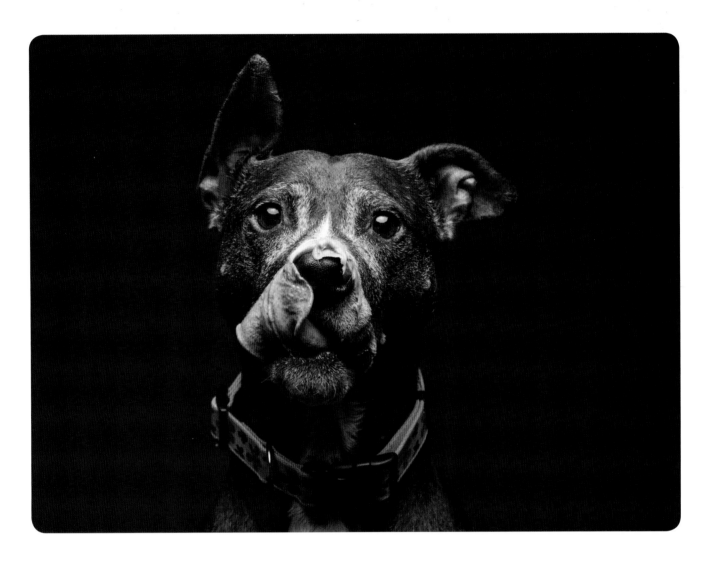

Koko

13 years old
Pit Bull

Found paralyzed, almost starved to death • Broken back healed • Learned to walk again • When happy and excited, starts racing and leaping about • Often goes crashing into things • Gets up smiling every time

Isaac

6 years old
American Bulldog/Pit Bull mix

Rescue • Nickname: The iFetch •
Ultimate wide receiver • Loves making
giant leaps into the air • Dearest,
gentlest boy • Tries so hard to do
whatever he thinks you want him to do

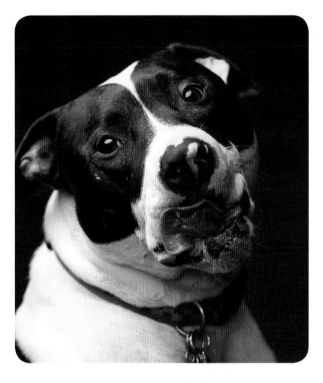

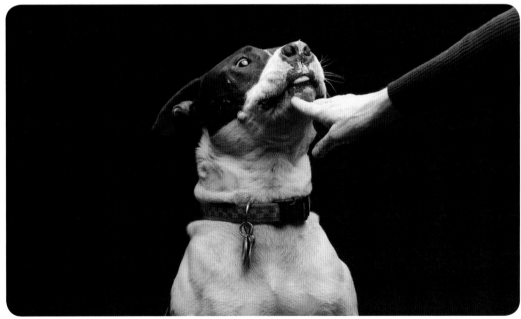

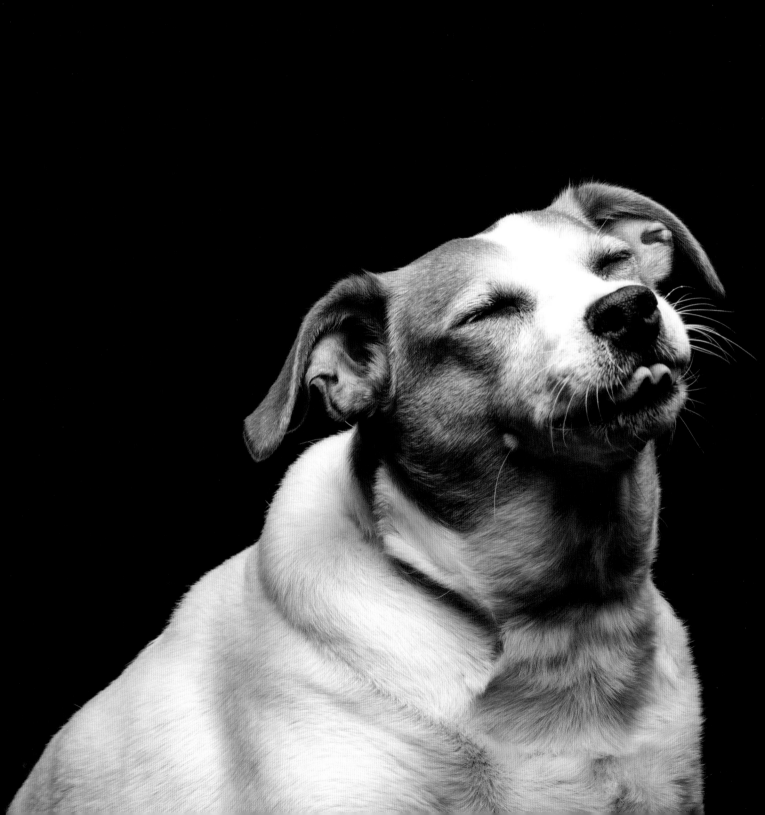

Ivy

7 years old
Jack Russell mix

Inquisitive • Chases squirrels
and rabbits • Can be an
extreme couch potato •
Favorite activity is receiving
a belly rub • Found through a
rescue group • Presented to
her family on Christmas Day

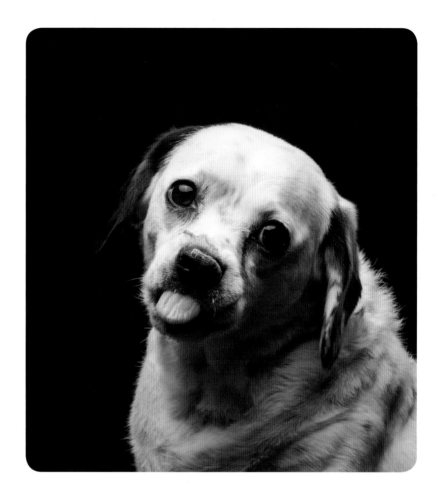

Ozzy Pawsborne

5 years old
Cavalier King Charles
Spaniel/Jack Russell Terrier
mix

Rescue • Perfect mix of
hyper and cuddly • Battling
lymphoma in chemotherapy
• Has no idea he has cancer
• Too busy playing Frisbee

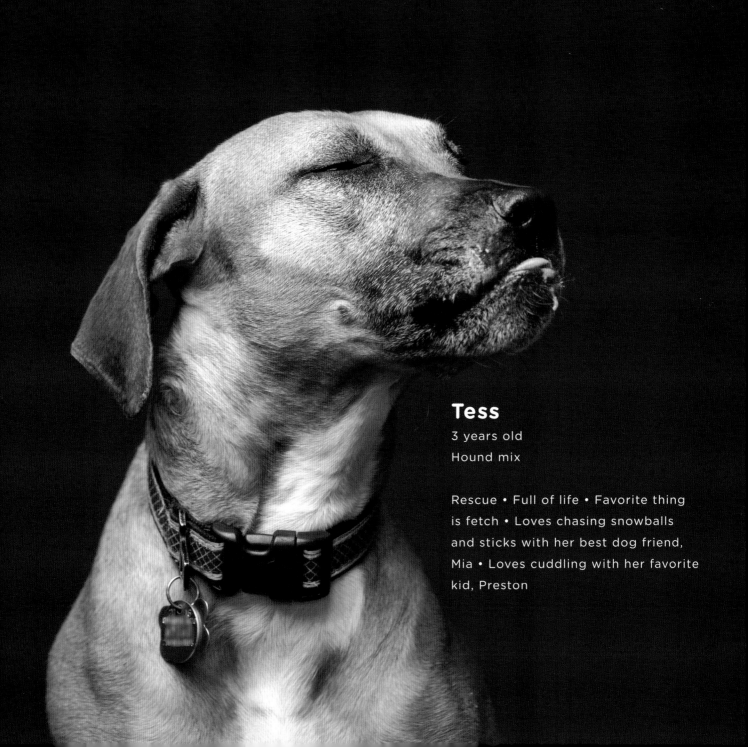

Tess

3 years old
Hound mix

Rescue • Full of life • Favorite thing
is fetch • Loves chasing snowballs
and sticks with her best dog friend,
Mia • Loves cuddling with her favorite
kid, Preston

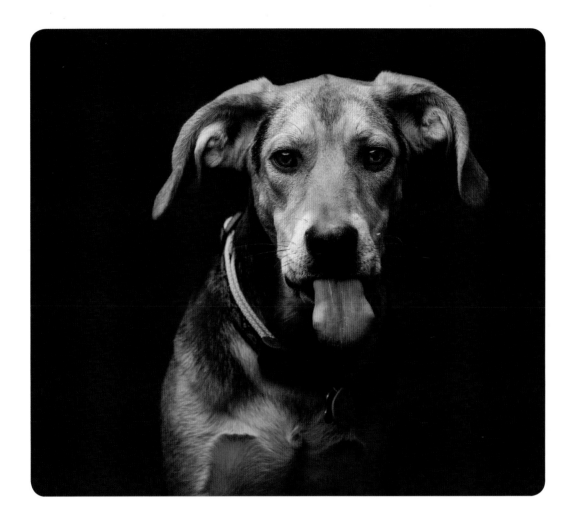

Lyla

7 months old
Black and Tan Coonhound/
German Shepherd mix

Rescue • Goofy heart • Plays with
two or three toys at one time •
Active and vocal participant when
family sings "You Ain't Nothing but
a Hound Dog"

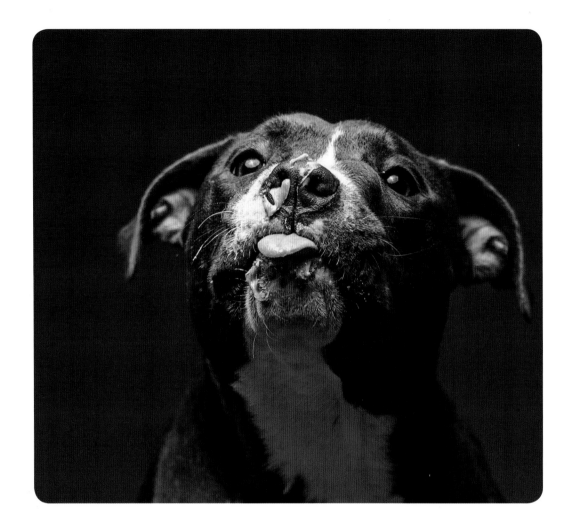

Rousey

2 years old
Pit Bull mix

Rescue • Sweet • Baby girl •
Loving • Wins the hearts of
everyone she meets

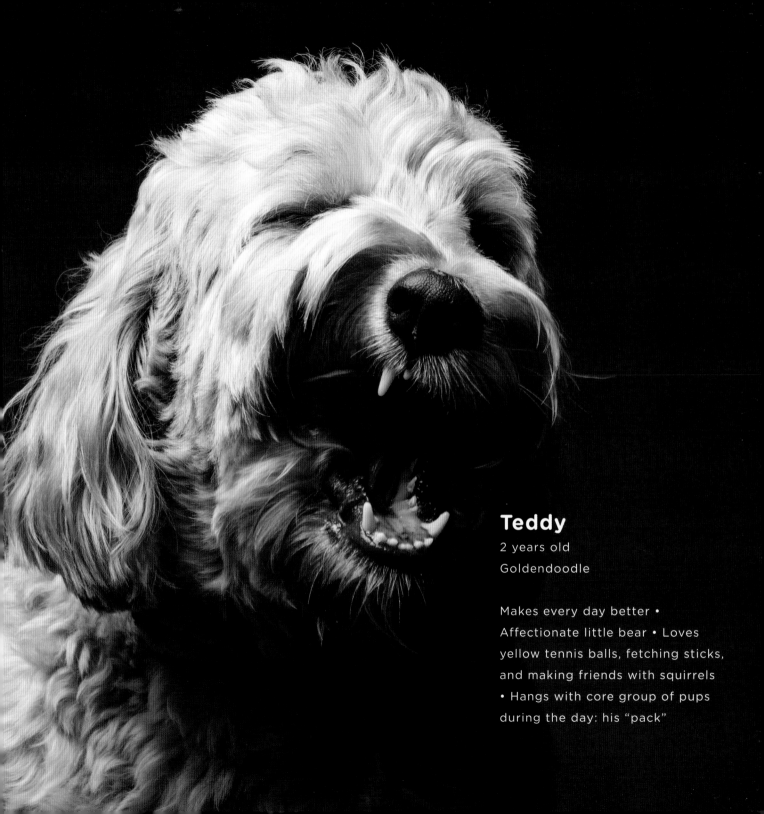

Teddy

2 years old
Goldendoodle

Makes every day better •
Affectionate little bear • Loves
yellow tennis balls, fetching sticks,
and making friends with squirrels
• Hangs with core group of pups
during the day: his "pack"

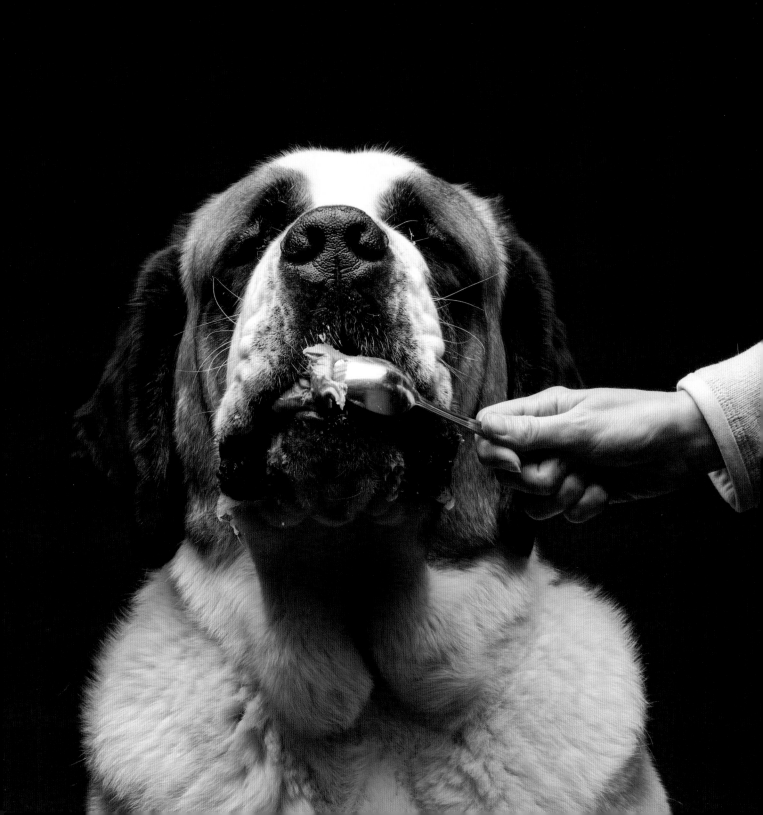

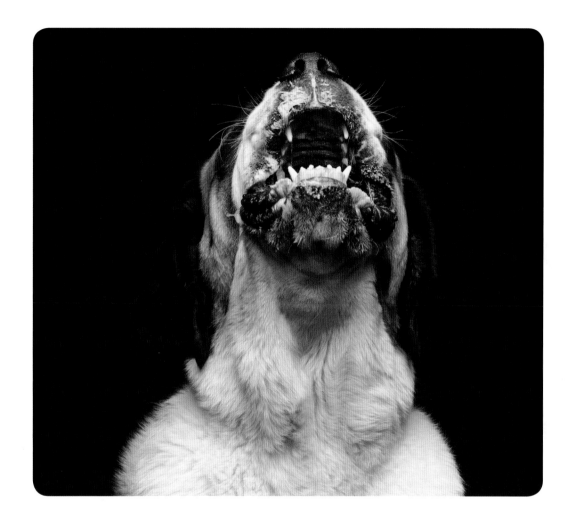

Jefferson

3 years old
Saint Bernard

Gentle giant • 165 pounds • Loves
to be on mom's lap • True to his
politician name, greets every dog at
the park • Uses his size to break up
fights • Nickname: The PhD of Pout

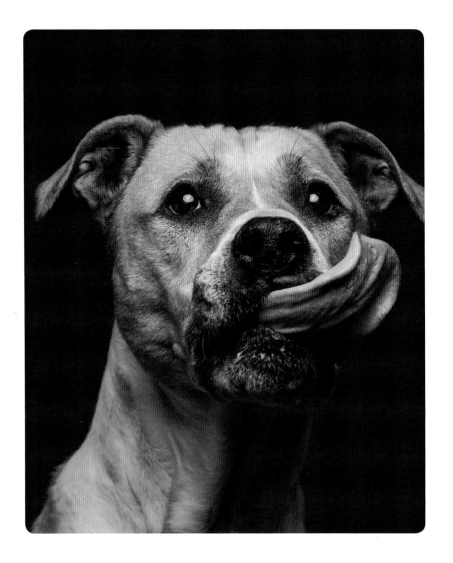

Jethro

5 years old
Coconut Retriever

Rescue • Loves to swim •
Will do anything for a tennis
ball • Brave • Snuggles for
hours on the weekend

Mazzy

12 years old
Pit Bull/Boxer mix

Rescue • Curious • Spunky • Sticks her butt in the air and
sneezes when she is excited • Taught her human: There's
always a better future when you're surrounded by love

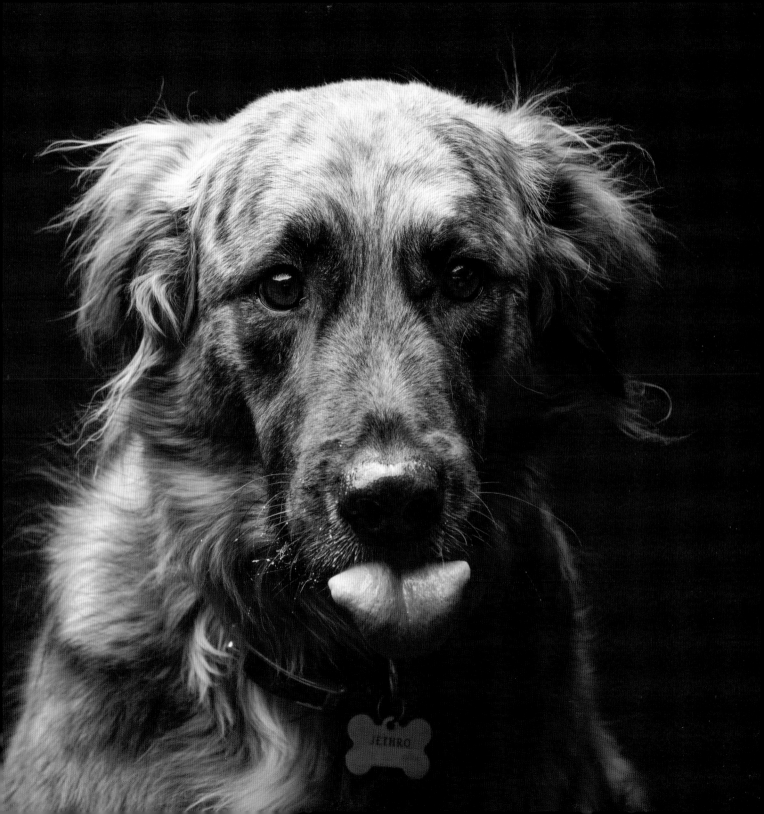

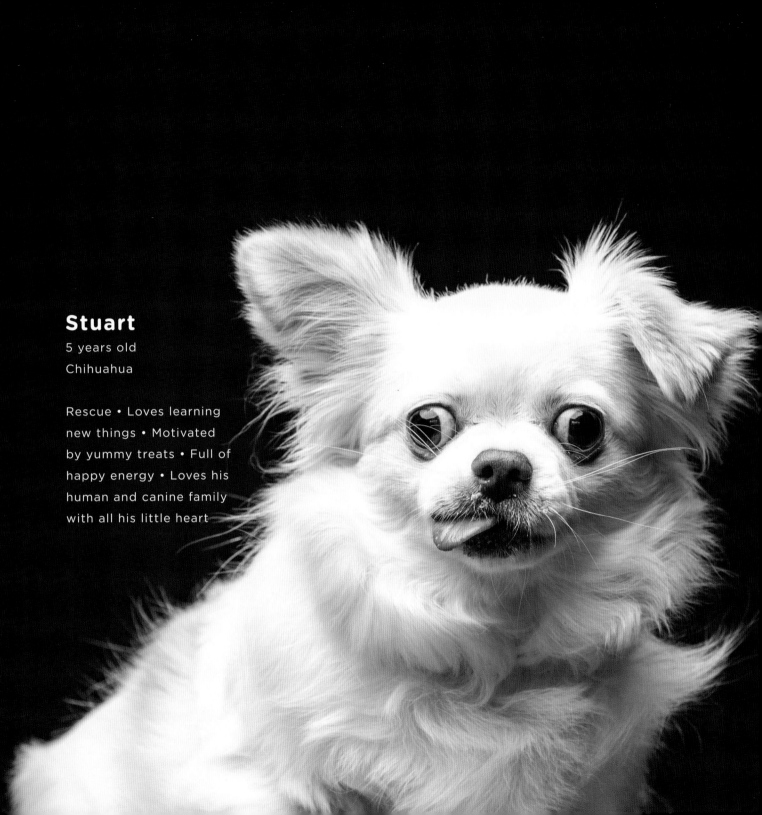

Stuart

5 years old
Chihuahua

Rescue • Loves learning
new things • Motivated
by yummy treats • Full of
happy energy • Loves his
human and canine family
with all his little heart

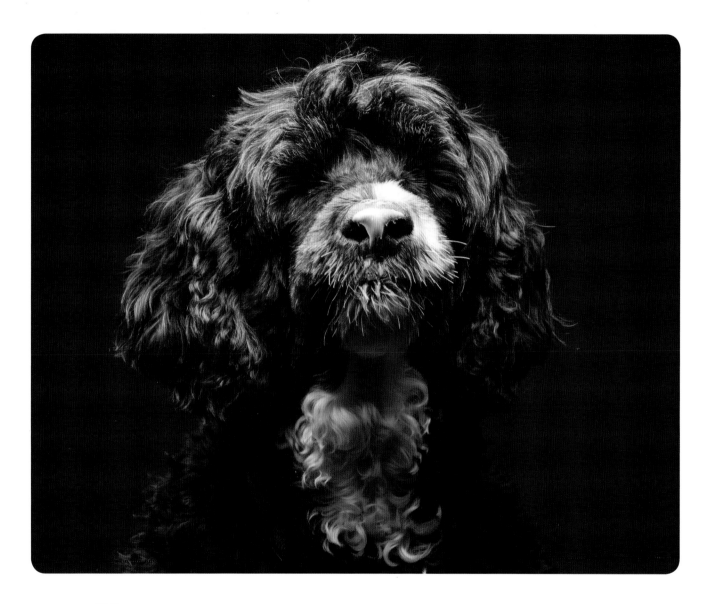

Rio

7 years old
Portuguese Water Dog

Curious • Constant • Always in motion, like a river • Brings laughter, love, and companionship to his family

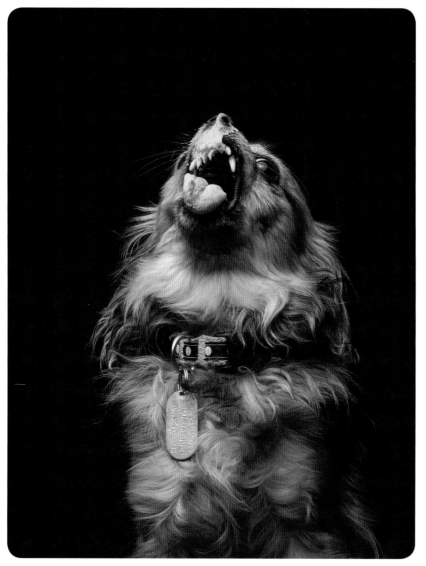

Penelope

3 years old

Papillion/Pomchi mix

Rescue • Likes to hide and pee on rugs • Chases squirrels, birds, and groundhogs, despite being smaller than most of them

Pierogi

8 years old

Shih Tzu/Yorkie mix

Disposition of Eeyore •
Loves cheese

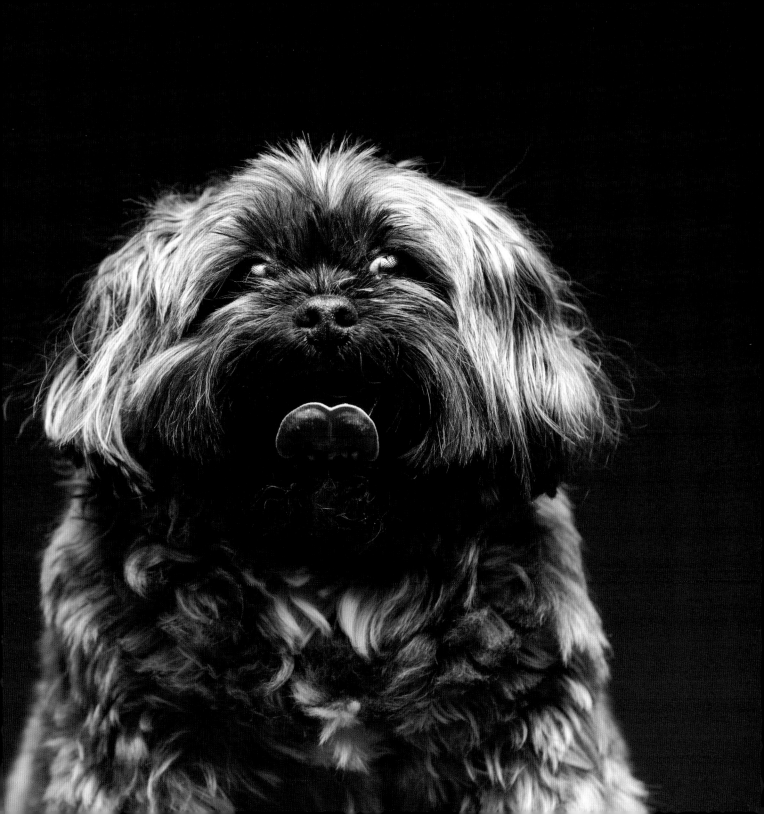

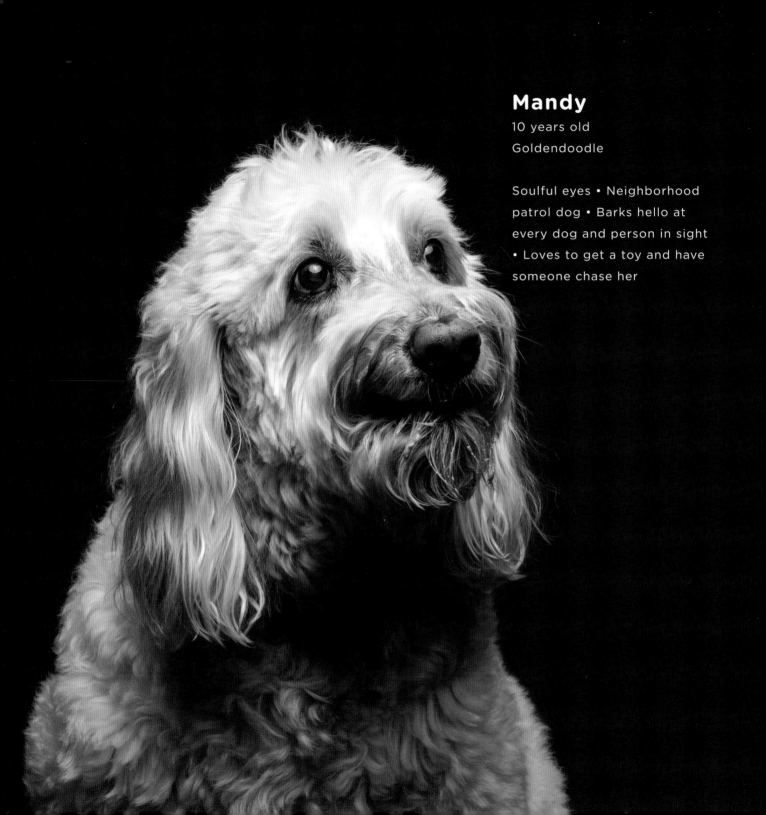

Mandy

10 years old
Goldendoodle

Soulful eyes • Neighborhood
patrol dog • Barks hello at
every dog and person in sight
• Loves to get a toy and have
someone chase her

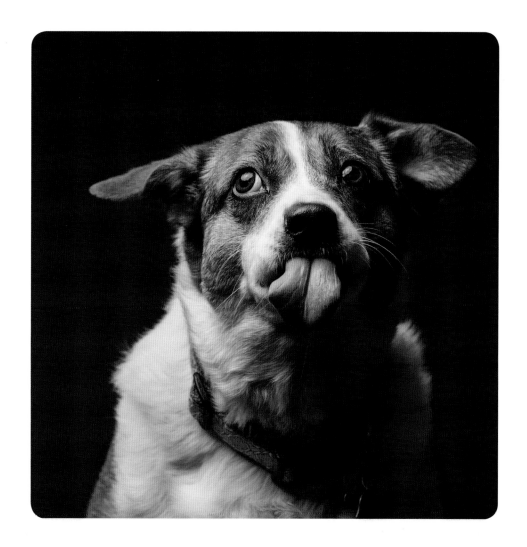

Ivy

5 years old
Unknown mix

Rescue • Loves people • Sticks
her head out the car window and
"bites" the air • Knows how to sit
at a picnic table and lick an ice
cream cone

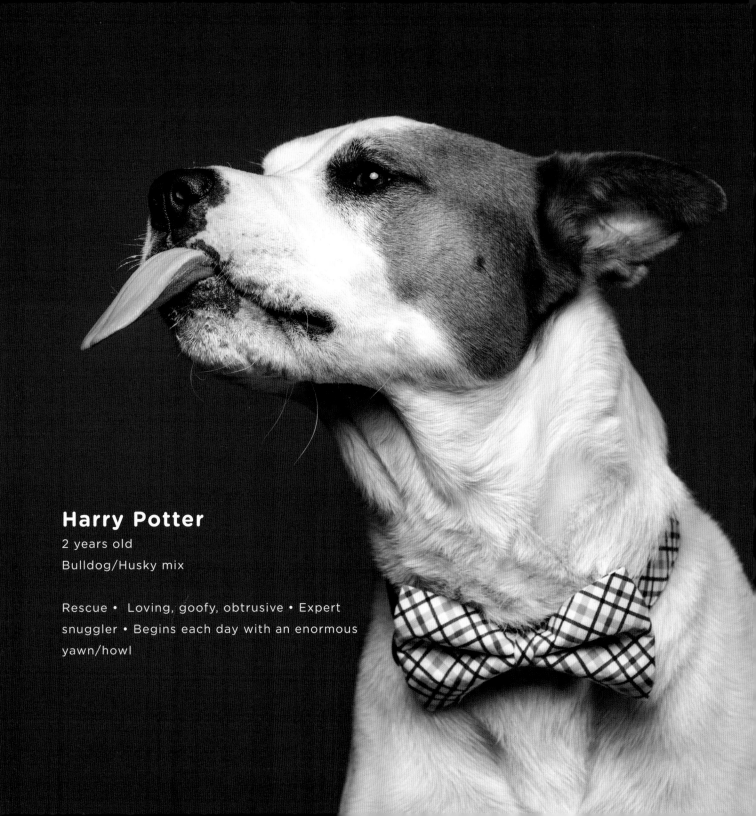

Harry Potter

2 years old
Bulldog/Husky mix

Rescue • Loving, goofy, obtrusive • Expert
snuggler • Begins each day with an enormous
yawn/howl

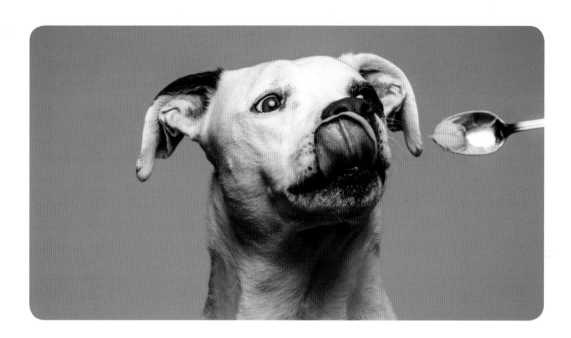

Petey

6 years old
Pit Bull mix

Rescue • Favorite thing: daycare with all his friends • Mama's boy • Sleeps beside his blind/deaf cocker spaniel sister, Arya, watching out for her • Such a sweetie

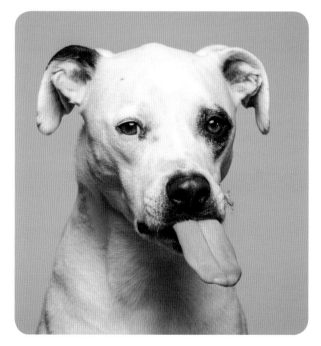

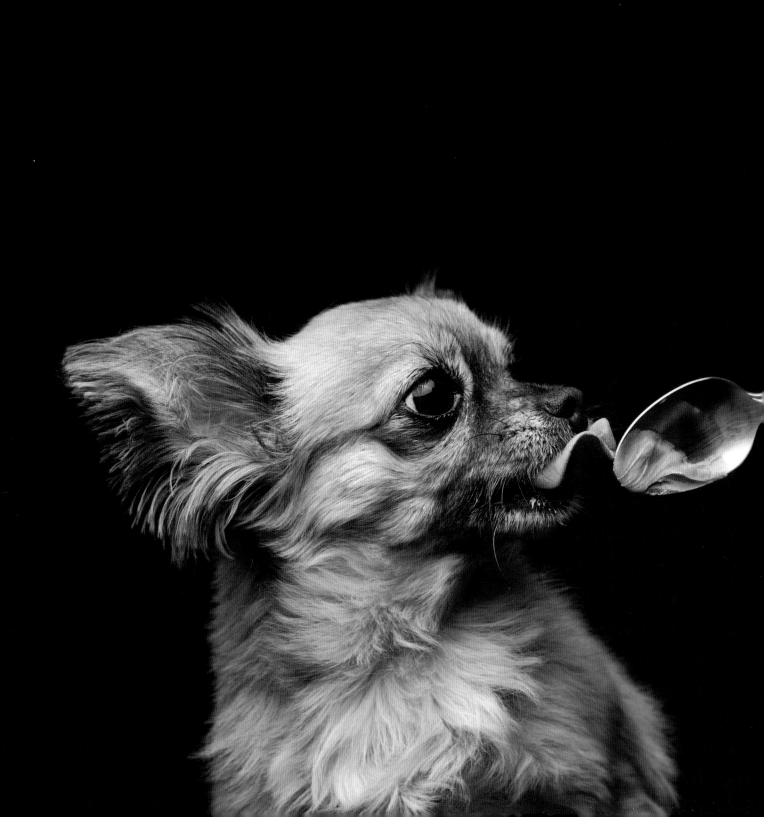

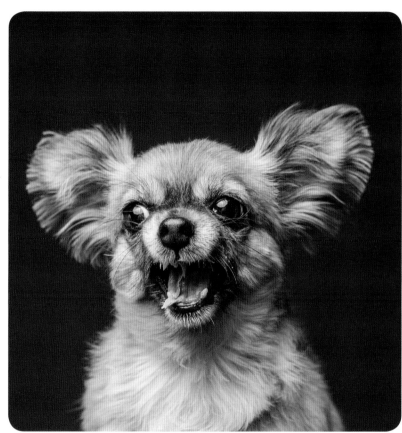

Mocha

6 years old
Longhaired Chihuahua

Cunning • Uses her good looks to manipulate people into
giving her food • Well-mannered • Has the heart of a lion

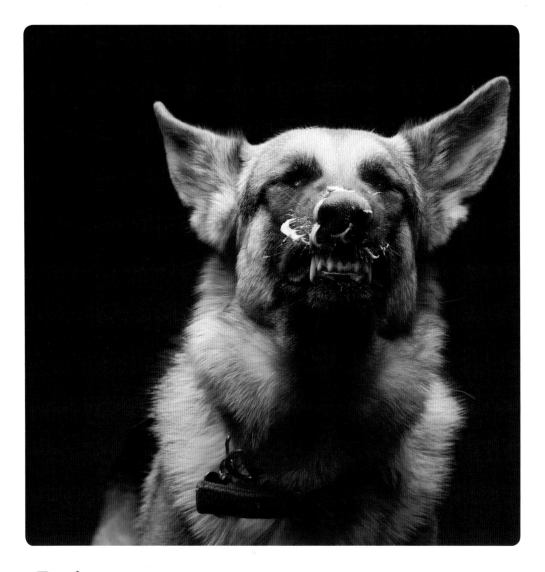

Taylor

2 years old
German Shepherd

Daycare enthusiast • Outgoing •
Loves playing chase and going
on long walks • Wrestles with her
siblings, Toby and Zeus

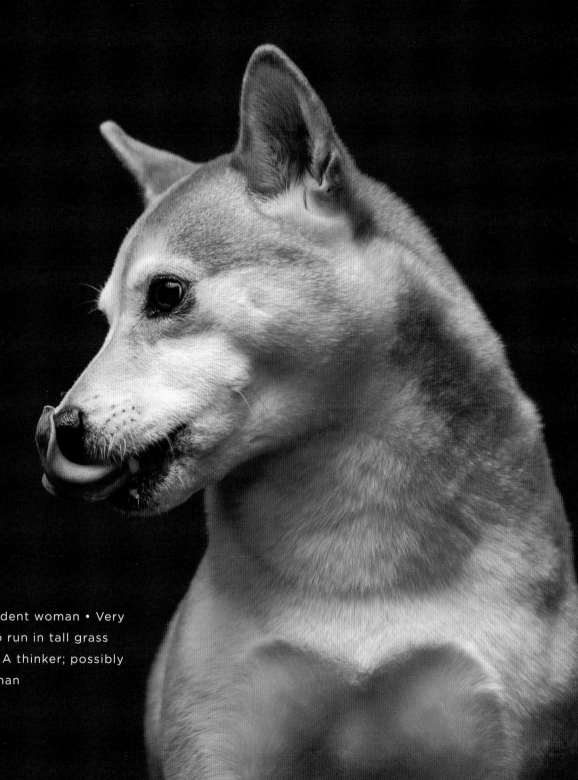

Smidge

8 years old
Shiba Inu

Rescue • An independent woman • Very
expressive • Loves to run in tall grass
looking for critters • A thinker; possibly
smarter than her human

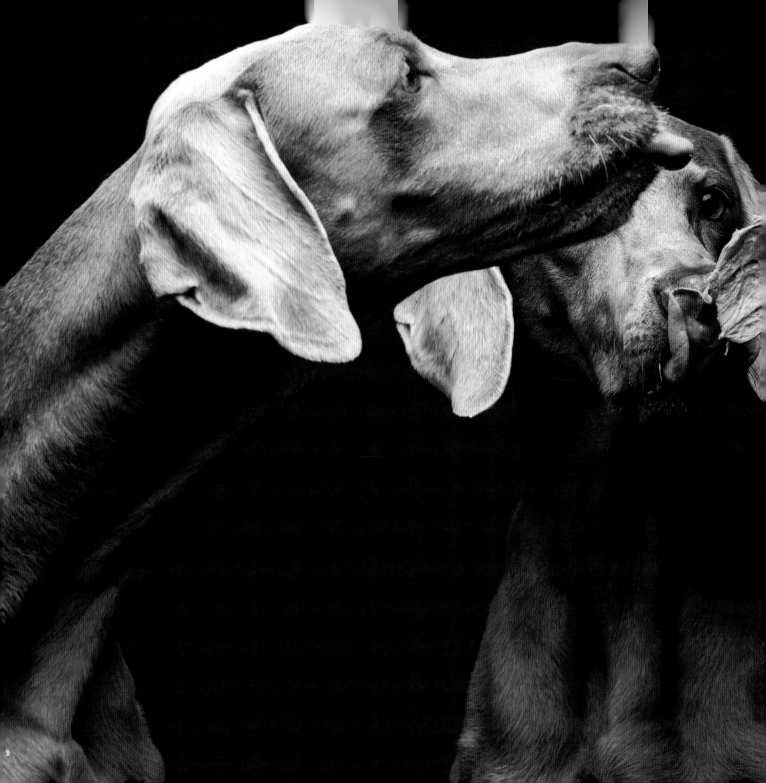

Lucy

8 years old
Weimaraner

Matured into a patient, playful girl • Therapy dog • Loved by kids, who read to her or include her in "getting to know you" games • Favorite pastime: performing autopsies on her stuffed toys

Scarlet

6 years old
Weimaraner

Miracle girl • Diagnosed with a diaphragmatic hernia • Recovered successfully from surgery • Forever a puppy • Playful • Counter surfer • Favorite thing to do: sleep

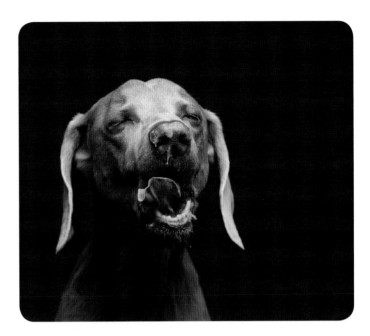

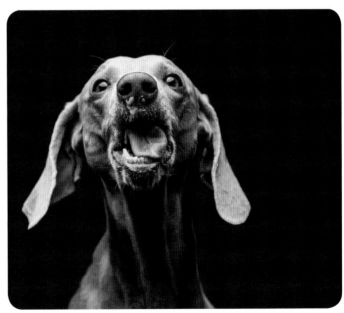

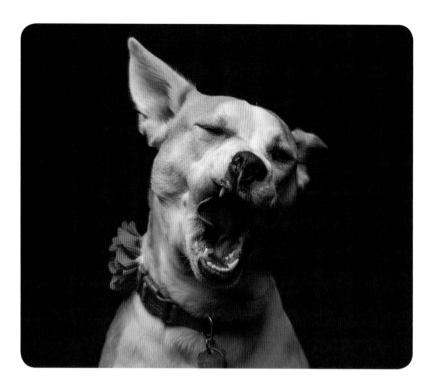

Widget

1 year old
Unknown mix

Rescue • Found her humans by following them home after a run one day • Loves water • Frolics in sprinklers • Very curious • Goes to work with her mom, a veterinarian

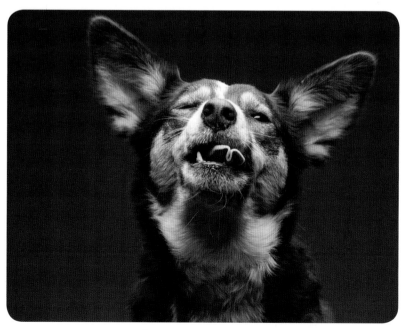

Sky

2 years old
Border Collie mix

Rescue • Loves to chase balls • Very smart • Recognizes people by name

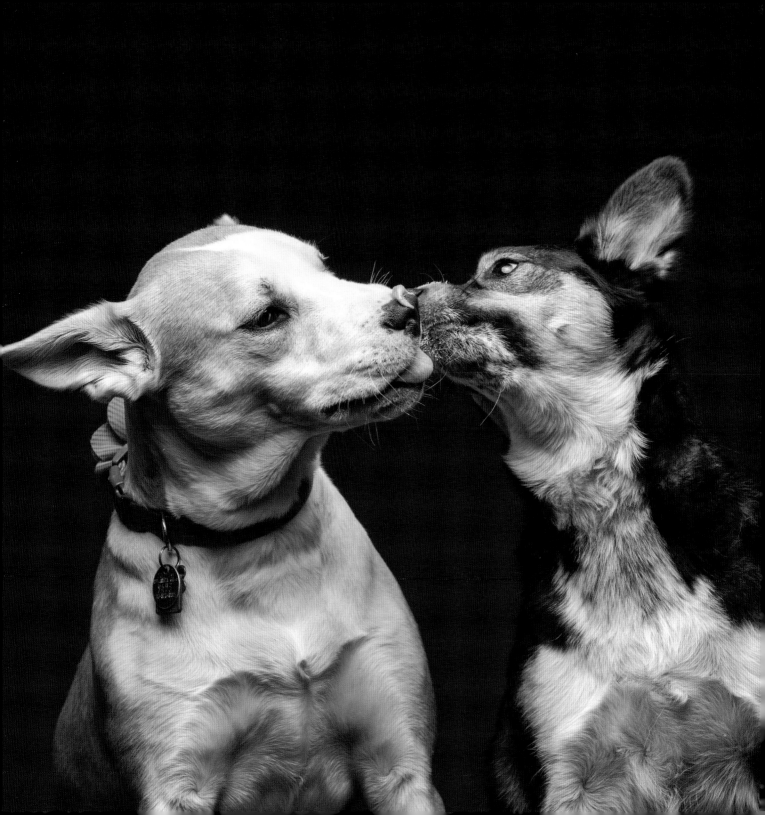

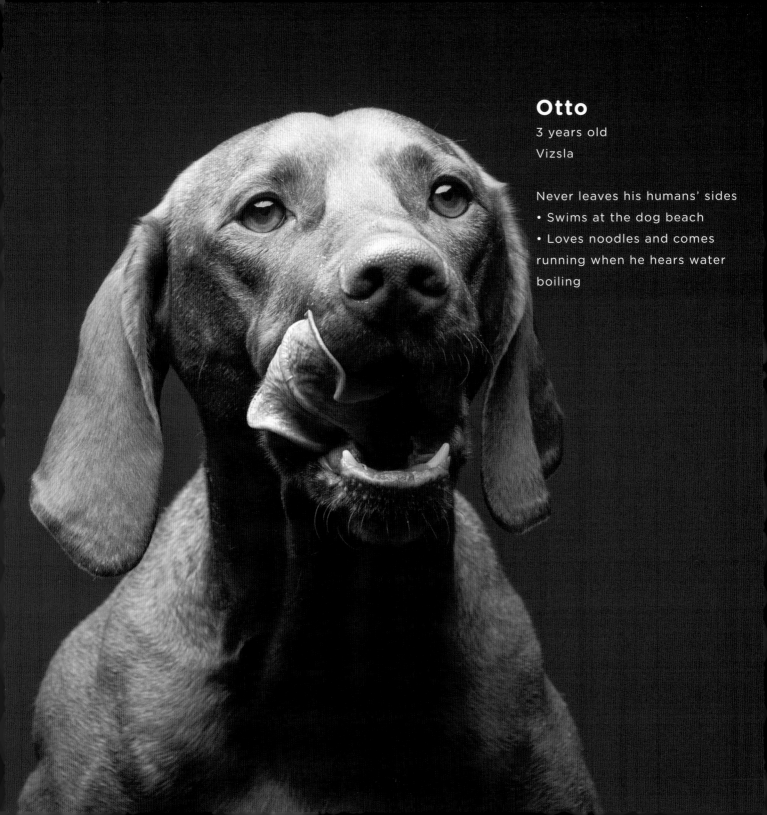

Otto

3 years old
Vizsla

Never leaves his humans' sides
• Swims at the dog beach
• Loves noodles and comes
running when he hears water
boiling

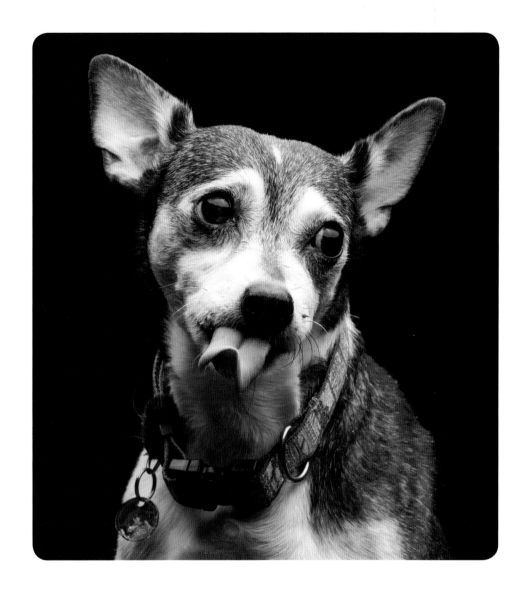

Lily

11 years old
Toy Fox Terrier

Adopted from a sanctuary
for senior dogs • Keeps an
eye on her mom at all times •
Absolute sweetheart

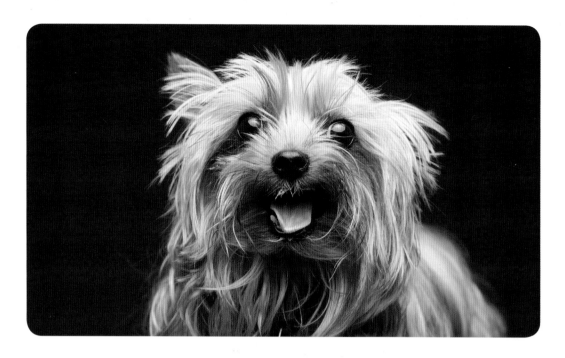

Maya

5 years old
Yorkie

Has no personal boundaries •
Extremely fun loving • Perhaps a
little possessed • Loves to play •
Sister to Monty • Named after the
great Maya civilization

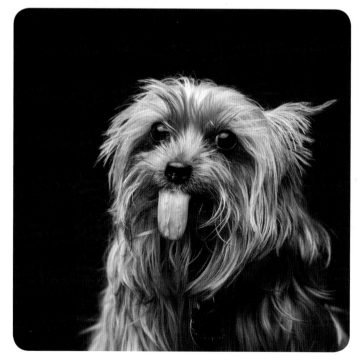

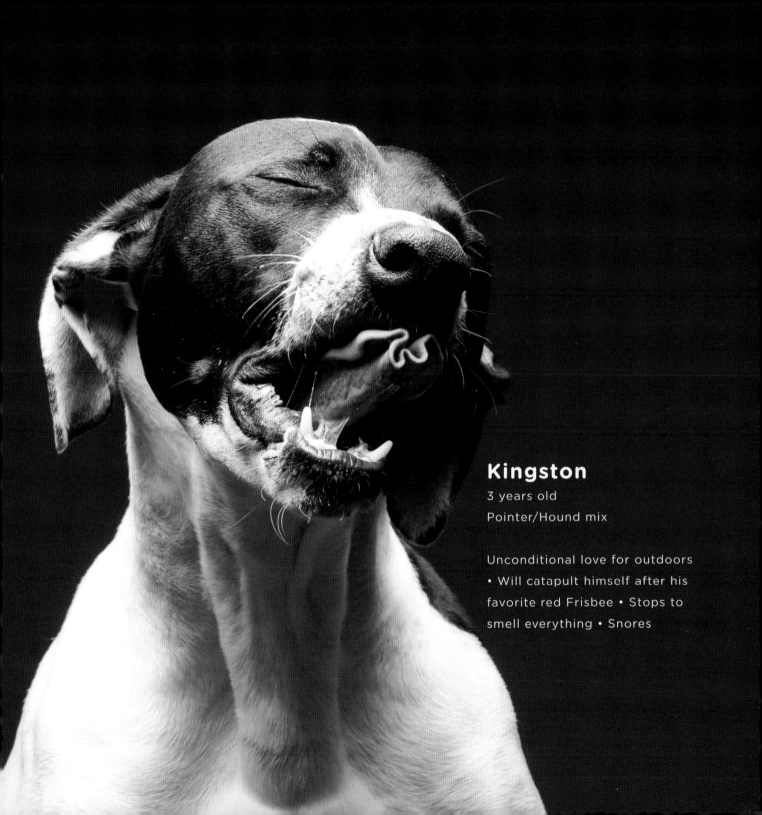

Kingston
3 years old
Pointer/Hound mix

Unconditional love for outdoors
• Will catapult himself after his
favorite red Frisbee • Stops to
smell everything • Snores

Penny

14 years old

German Shepherd mix

Rescue • Loves to fetch sticks • Avid
squirrel hunter • Takes her medications with
her favorite food, peanut butter

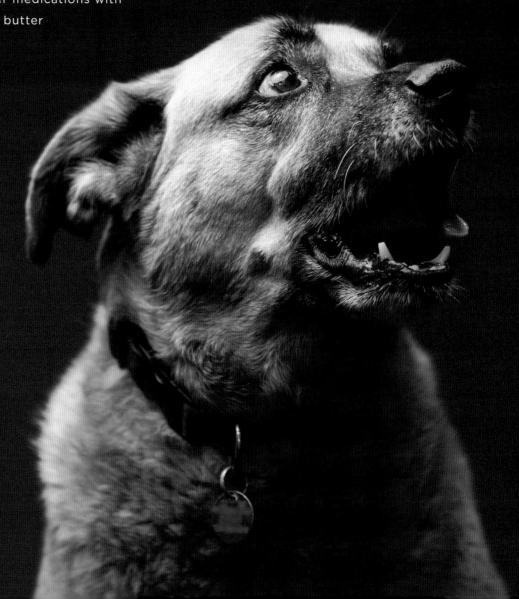

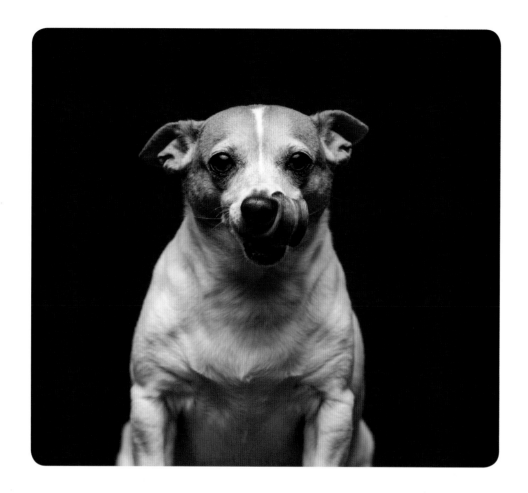

Little Foot

7 years old
Chihuahua

Loves to snuggle • Favorite toy:
her blue ball • Sister to Pierogi

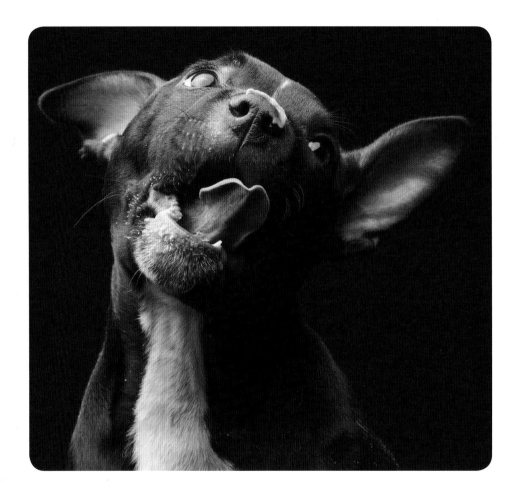

Louie

2 months old
Pit Bull

Rescue • Just a pup • Quickly
becoming the man of the house
• Brother to Lola

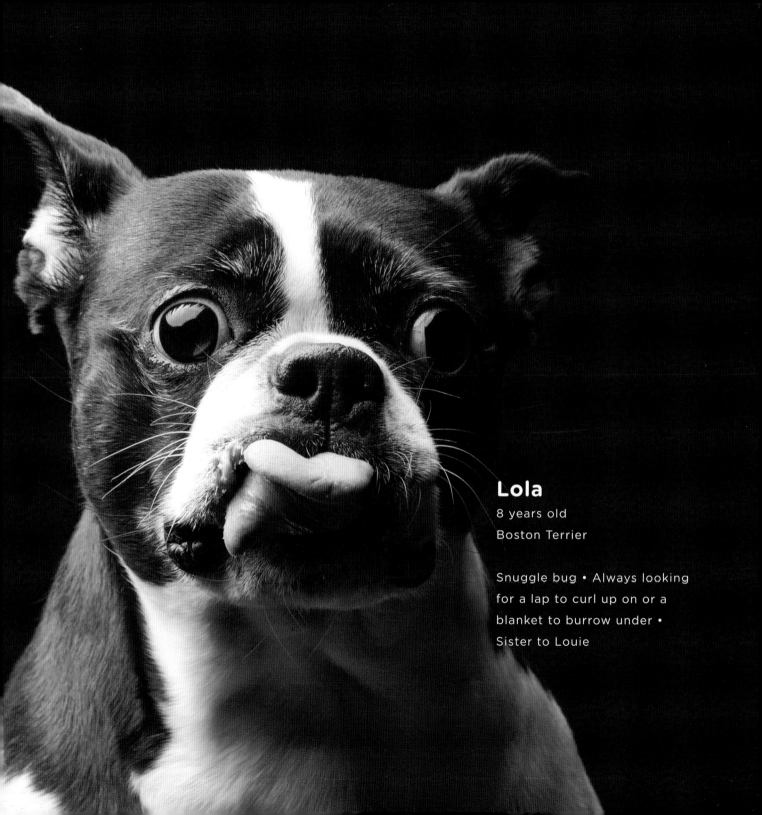

Lola

8 years old
Boston Terrier

Snuggle bug • Always looking
for a lap to curl up on or a
blanket to burrow under •
Sister to Louie

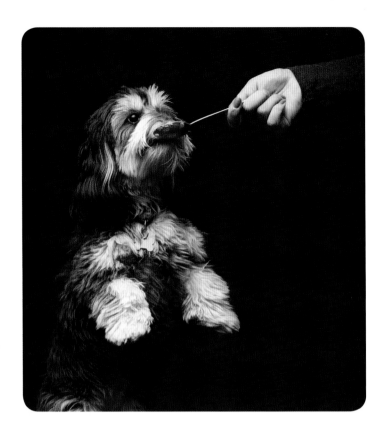

Fiona

1 year old
Longhaired/Wirehaired Dachshund mix

Full of energy and spunk • Loves sitting
with Penny on the balcony in sunspots •
Gives non-stop kisses

Penny

4 years old
Longhaired Miniature Dachshund

Loves to sit on laps and be pet
all day long • Runs laps with
Fiona around the house • Makes
everyone feel loved

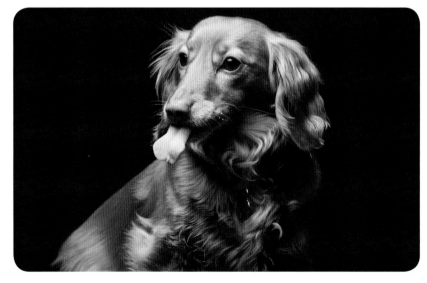

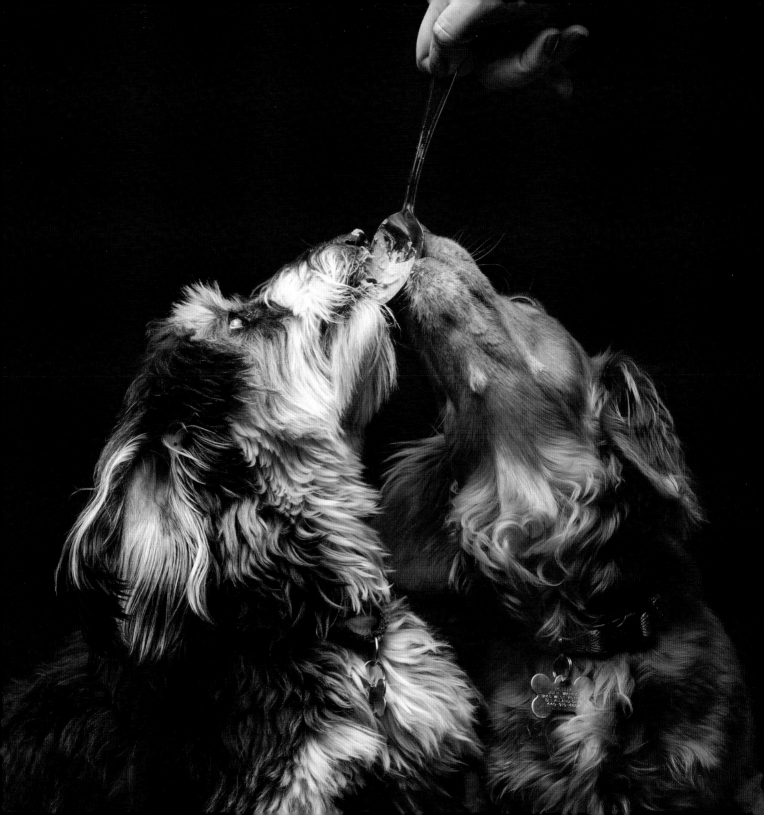

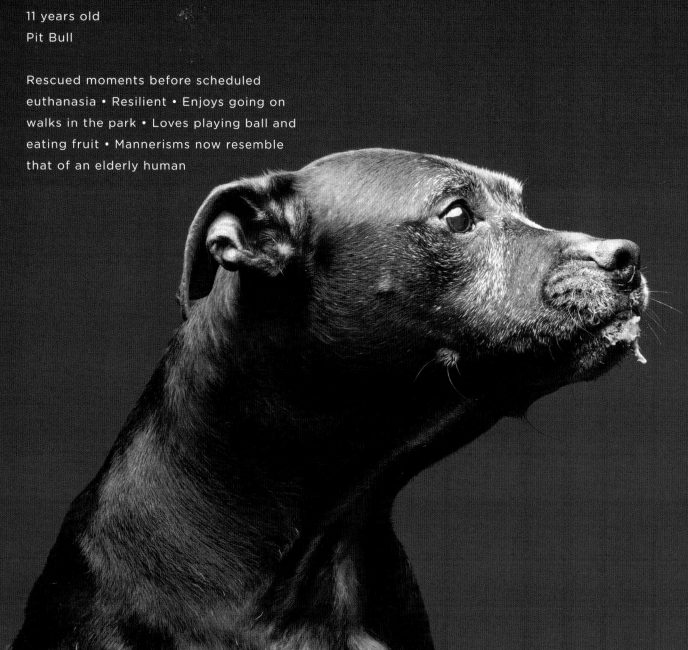

Preston

11 years old
Pit Bull

Rescued moments before scheduled
euthanasia • Resilient • Enjoys going on
walks in the park • Loves playing ball and
eating fruit • Mannerisms now resemble
that of an elderly human

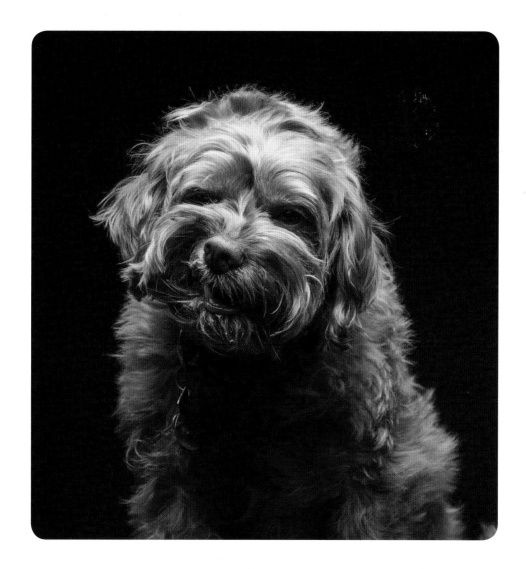

Rudy

4 years old
Miniature Red Labradoodle

Eager to please • Runs full tilt
and repeatedly after a stick well-
thrown • Loves exploring sounds
and smells of the beach

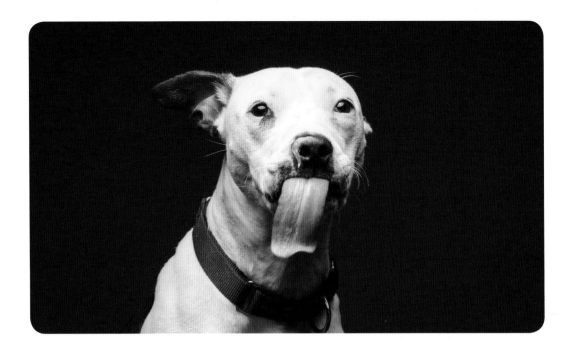

Frankie

7 months old
American Pit Bull/Terrier mix

Fun-loving foster • An old soul •
Wise, strong, brave • A therapy
dog in the making

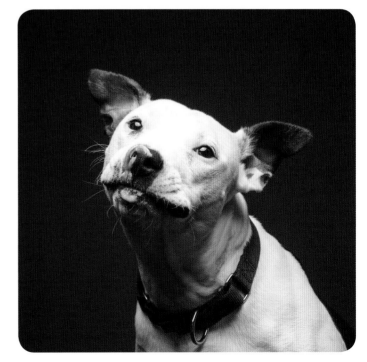

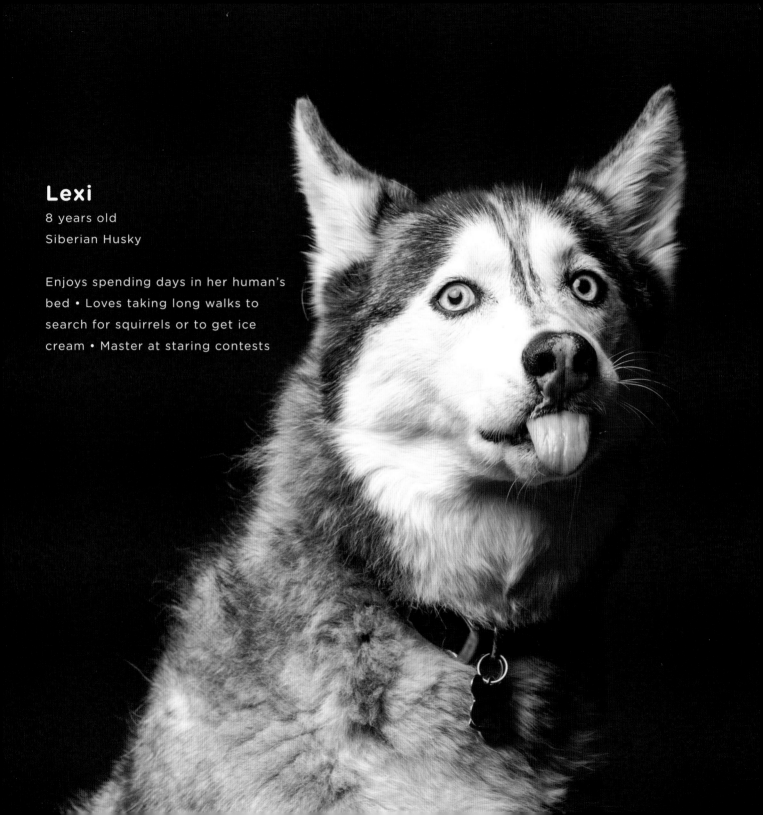

Lexi

8 years old
Siberian Husky

Enjoys spending days in her human's bed • Loves taking long walks to search for squirrels or to get ice cream • Master at staring contests

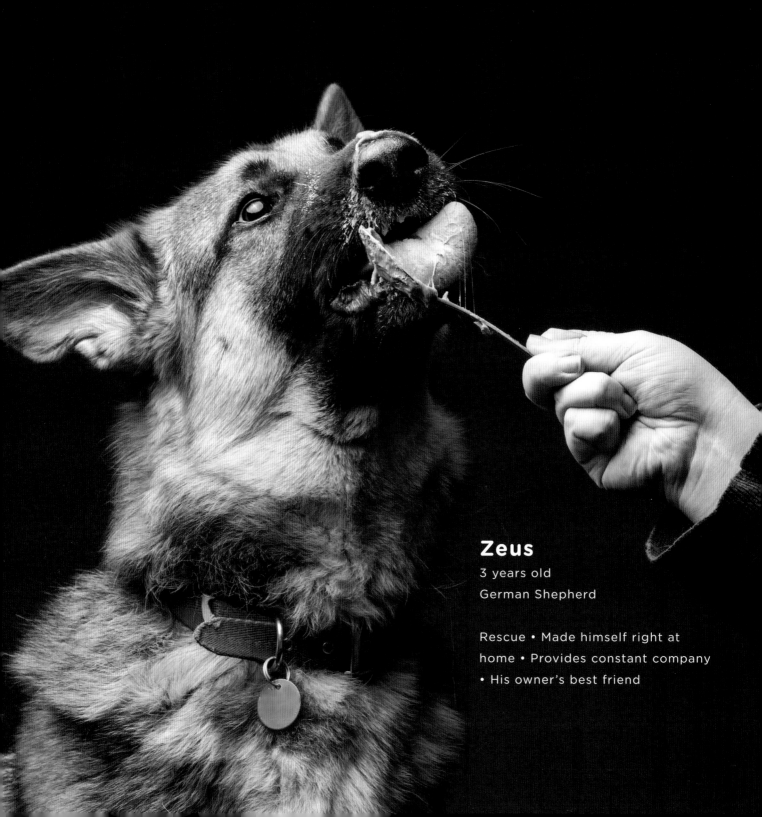

Zeus

3 years old
German Shepherd

Rescue • Made himself right at
home • Provides constant company
• His owner's best friend

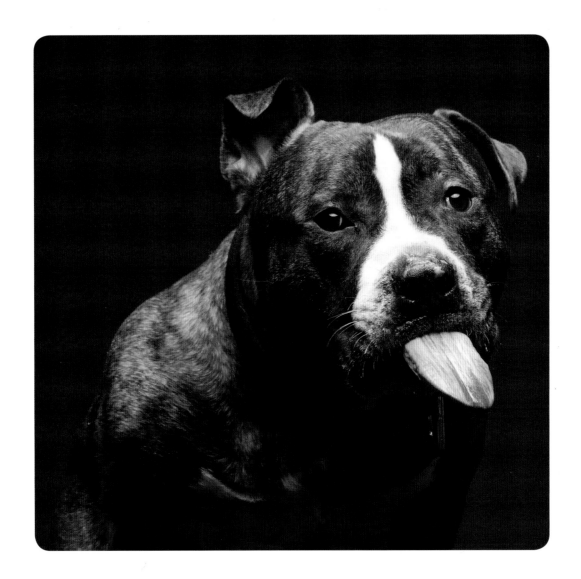

Mac

7 years old
Mastiff/Pit Bull mix

Inspired his human to run a local pit bull rescue • Helps find stray dogs • Acclimates new fosters to his home • Shares his confidence with fearful dogs • Will do anything for a ball

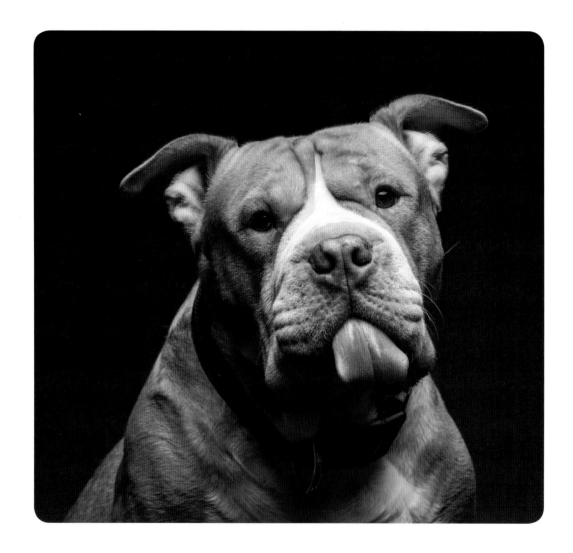

Atilla

4 years old
Chinese Shar-Pei/Pit Bull mix

Rescue • Goofy • Tries to catch the hose water in the summer • Perfect protector against monsters lurking in his (human) brother's closet

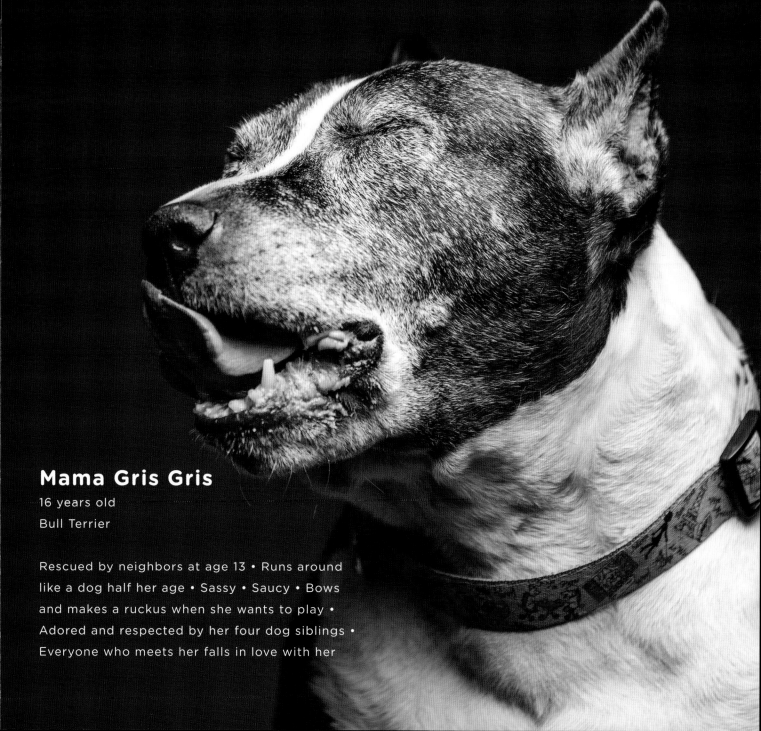

Mama Gris Gris

16 years old
Bull Terrier

Rescued by neighbors at age 13 • Runs around
like a dog half her age • Sassy • Saucy • Bows
and makes a ruckus when she wants to play •
Adored and respected by her four dog siblings •
Everyone who meets her falls in love with her

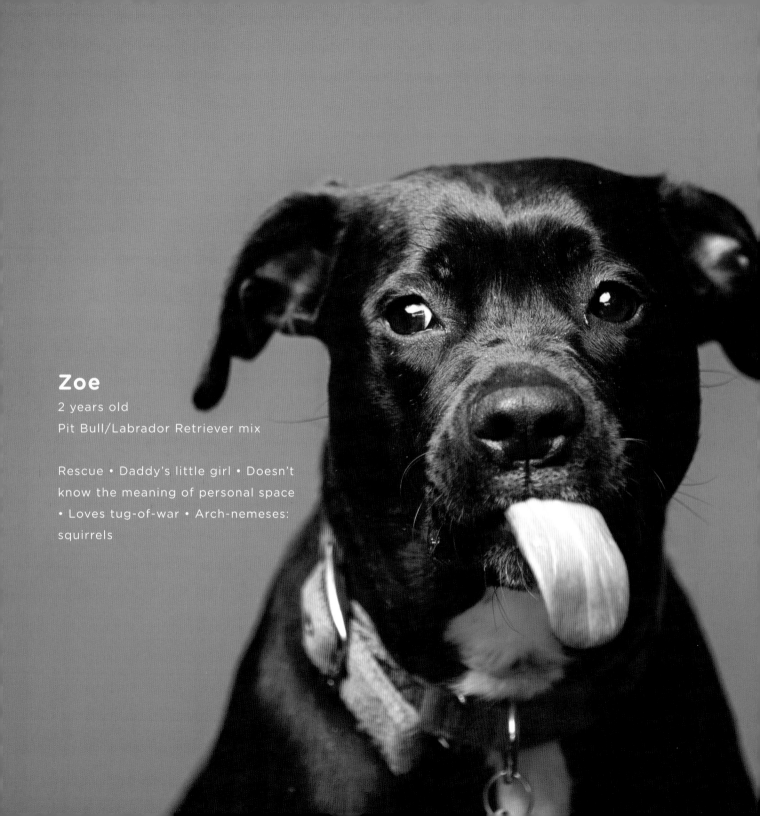

Zoe
2 years old
Pit Bull/Labrador Retriever mix

Rescue • Daddy's little girl • Doesn't know the meaning of personal space • Loves tug-of-war • Arch-nemeses: squirrels

Lulu

5 years old
Boston Terrier/Bulldog mix

Gentle • Loves to chew on antlers • Frequents local coffee shop on weekends • Shows unconditional love by tail wagging and booty shaking

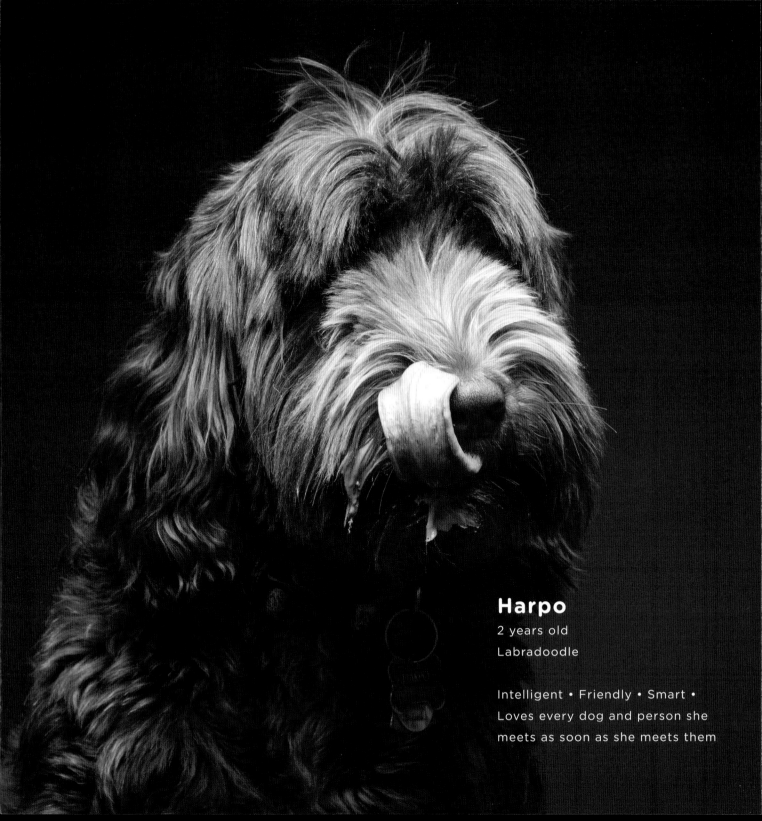

Harpo

2 years old
Labradoodle

Intelligent • Friendly • Smart •
Loves every dog and person she
meets as soon as she meets them

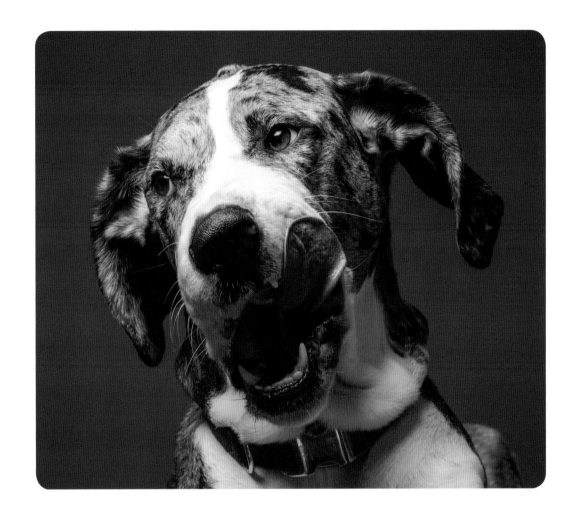

Sadie

4 years old
Great Dane

Loves zooming in the yard • Can't seem to cuddle close enough • Sits on the couch like a human • Has a heart as big as she is

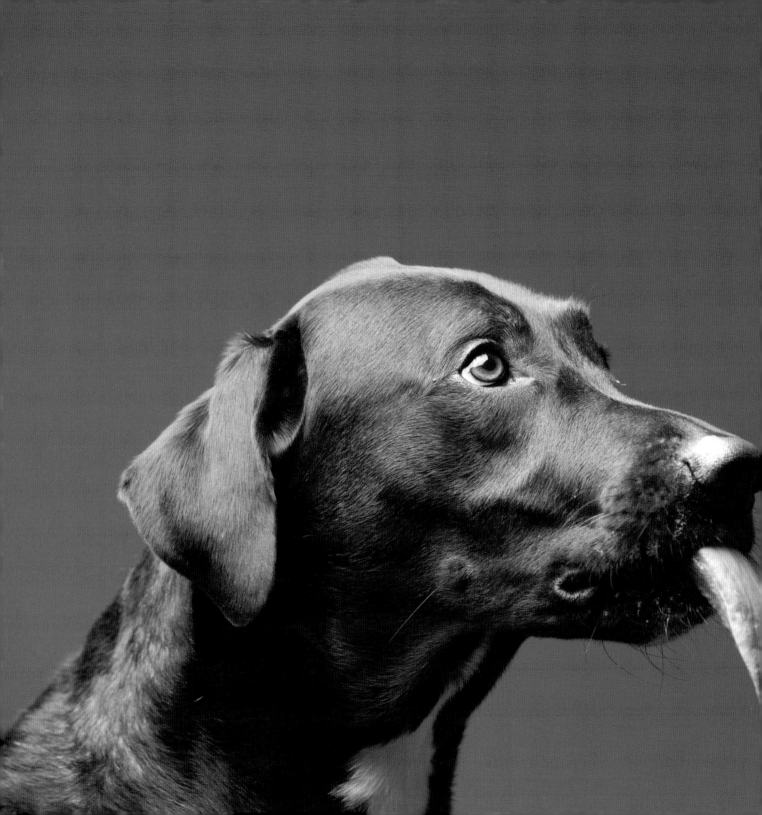

Oliver

5 years old
Labrador Retriever mix

Rescue • Loves hiking • Takes long walks • Missed the retriever memo • Will rarely fetch a ball

Sadie

3 years old
Pit Bull

Rescue • A little clown • Expressive ears • Will fetch all day long • Barks and growls in her sleep

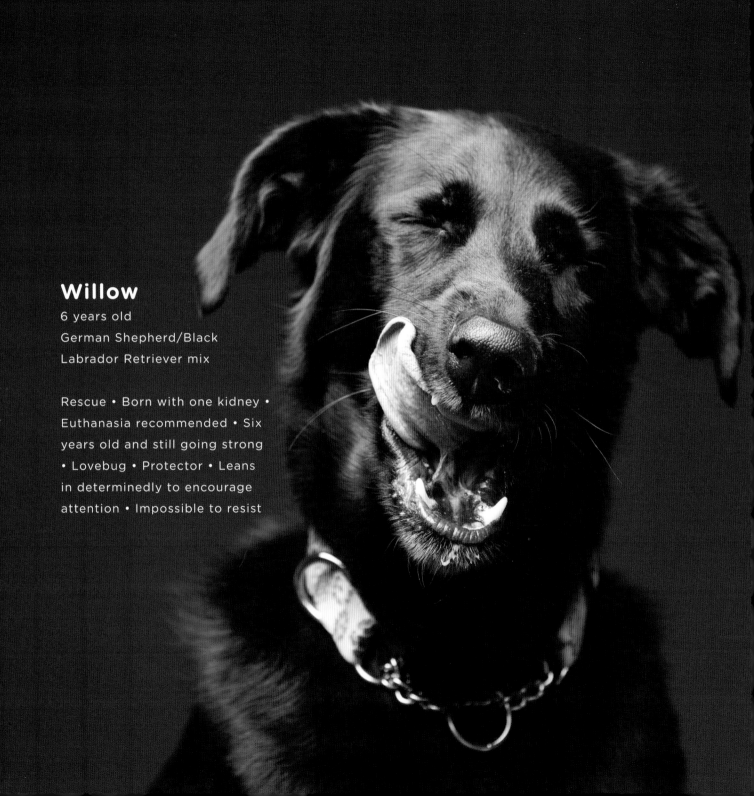

Willow

6 years old
German Shepherd/Black
Labrador Retriever mix

Rescue • Born with one kidney •
Euthanasia recommended • Six
years old and still going strong
• Lovebug • Protector • Leans
in determinedly to encourage
attention • Impossible to resist

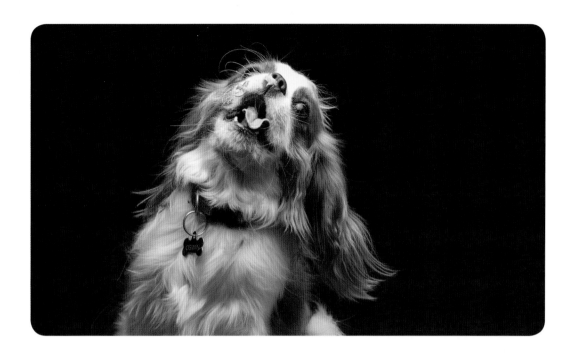

Oswin

1 year old
Cavalier King Charles Spaniel

Sweet tempered • Fearless • Loves
long walks and short workweeks
• Favorite agility class activity:
running through the tunnel

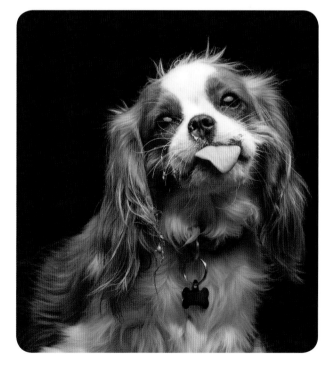

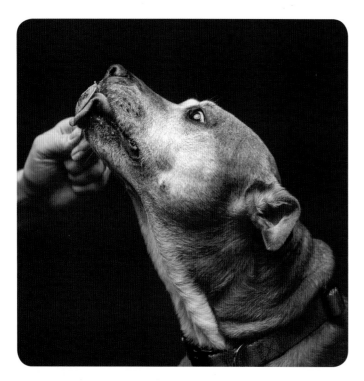

Sandy

12 years old
Pit Bull Terrier mix

Rescue • Cuddler • Snores like a freight train • Loves tennis balls and tennis balls only • Comes running when the peanut butter jar is opened

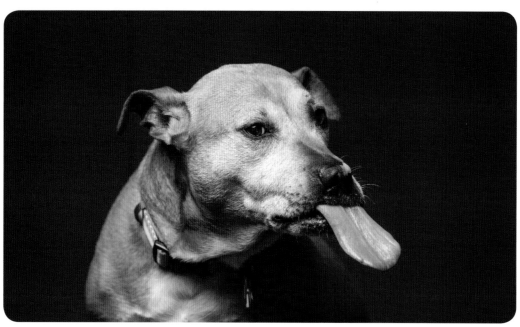

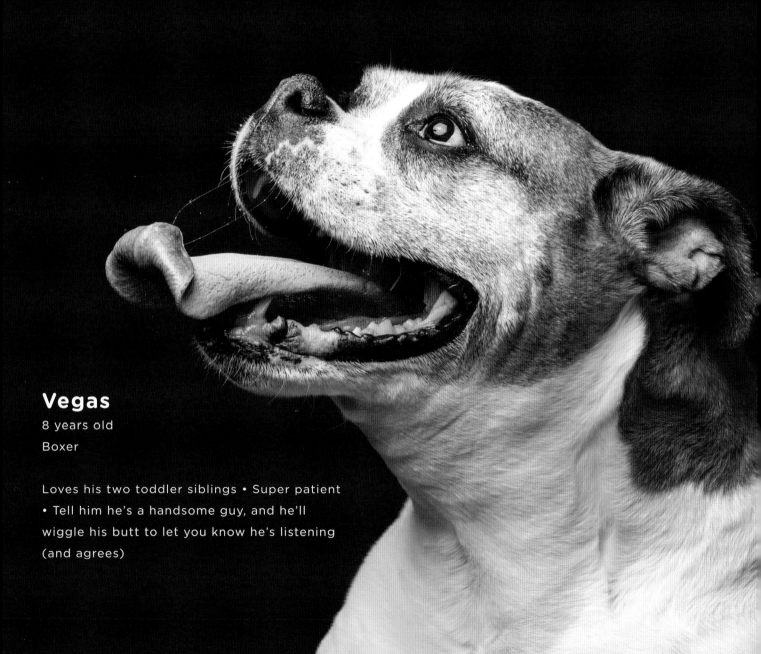

Vegas

8 years old
Boxer

Loves his two toddler siblings • Super patient
• Tell him he's a handsome guy, and he'll
wiggle his butt to let you know he's listening
(and agrees)

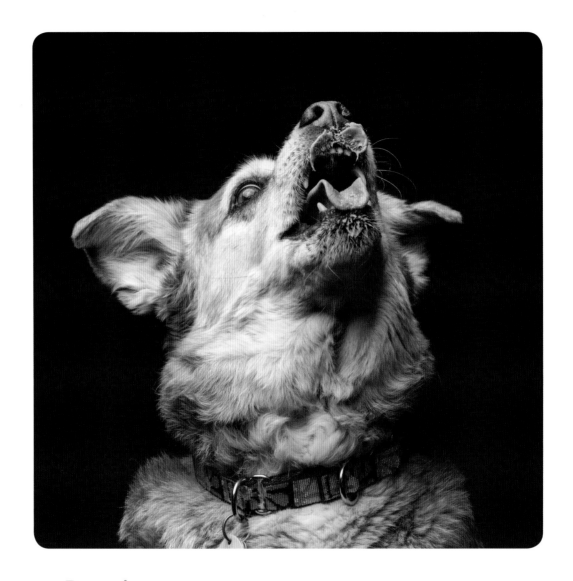

Brandy

11 years old
Unknown mix

Rescue • Curious • Sweet • Loves
car rides if it includes a stop at
Dairy Queen for a doggy treat

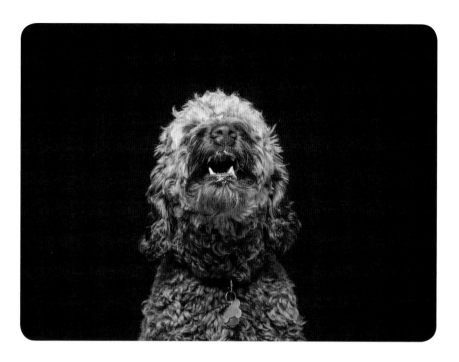

Kofi

1 year old
Labradoodle

Puts 200 percent effort into everything
he does • Dives for chewed gum on the
street to chew it for even a few seconds
before it's pulled out of his mouth •
Goes limp and pretends to be asleep to
avoid his crate • Loves everyone and
everything

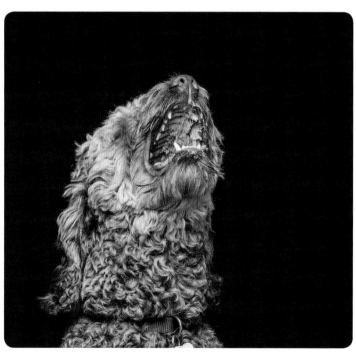

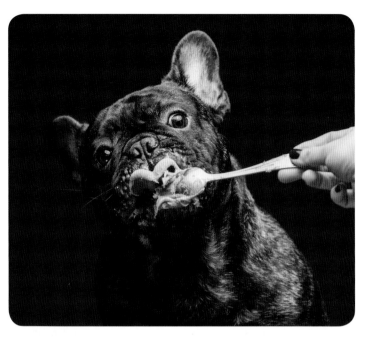

Hall & Oates

1 year old
French Bulldogs

Brothers • Littermates • Full of personality • Oates plays, snuggles, or gives kisses all hours of the day • Hall, more reserved and stubborn

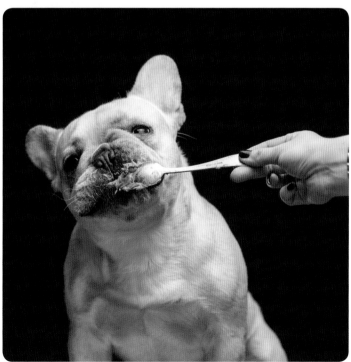

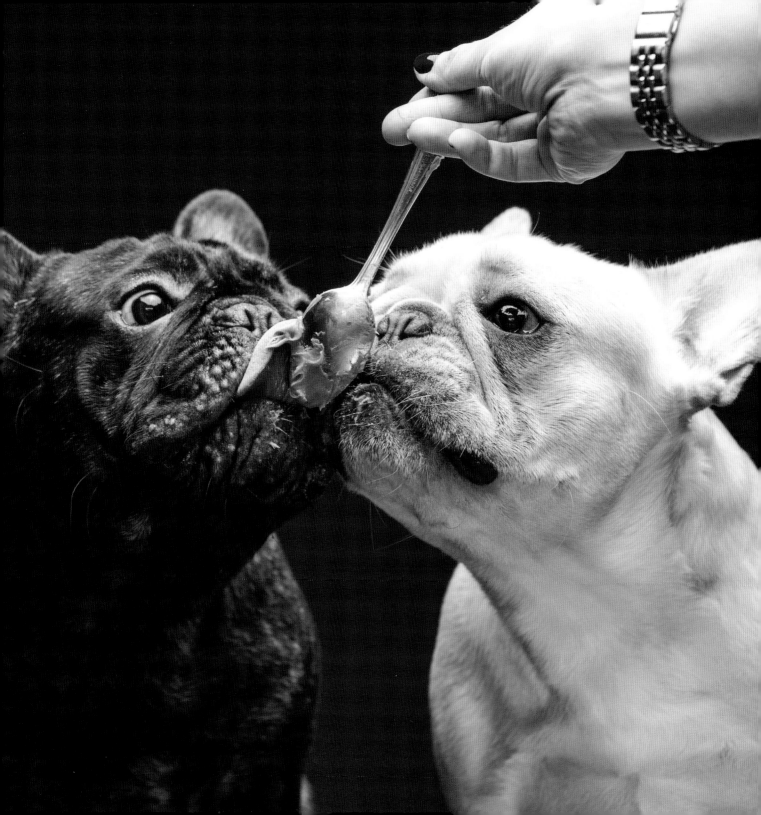

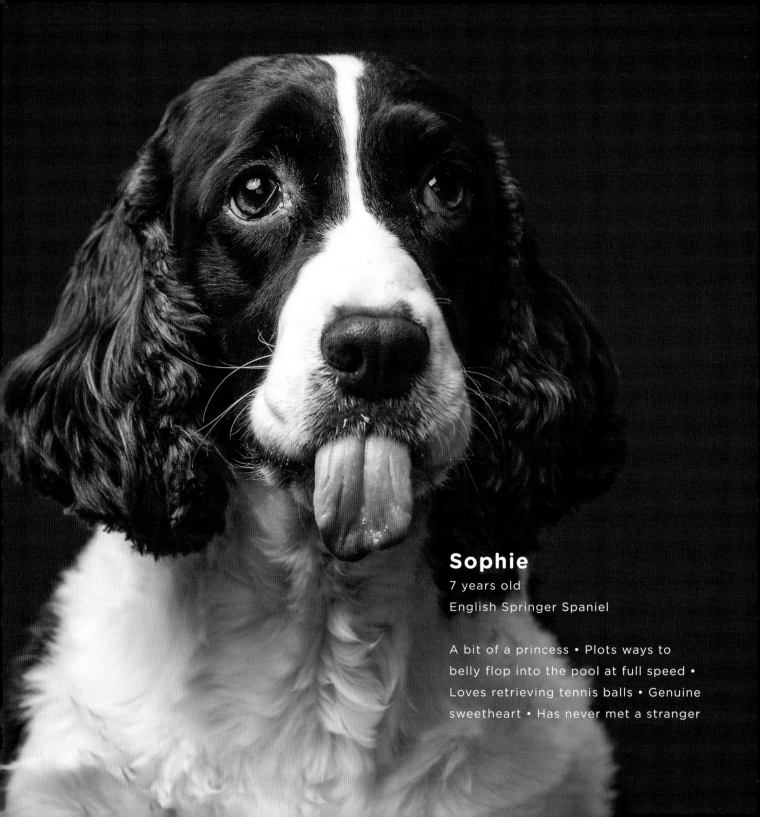

Sophie

7 years old
English Springer Spaniel

A bit of a princess • Plots ways to
belly flop into the pool at full speed •
Loves retrieving tennis balls • Genuine
sweetheart • Has never met a stranger

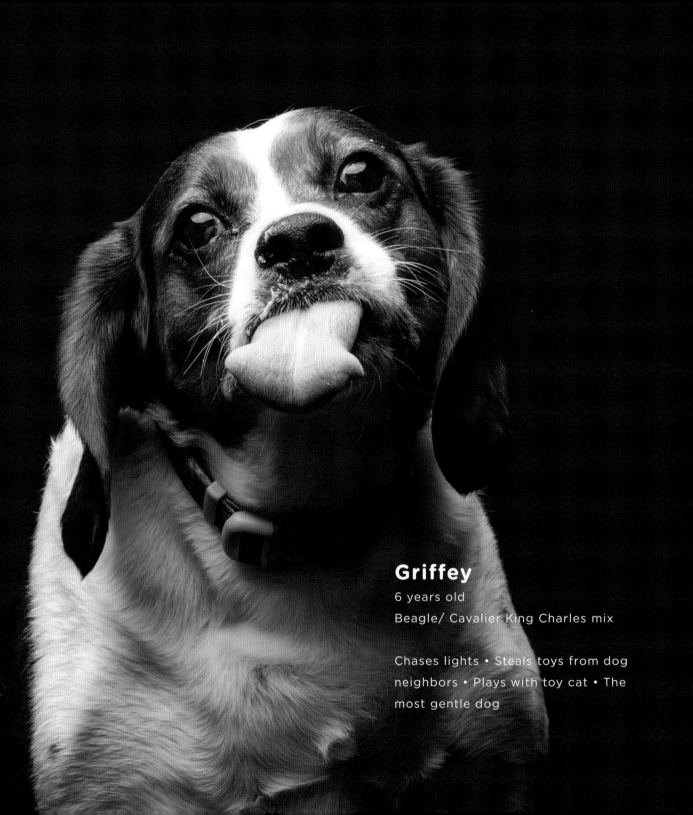

Griffey
6 years old
Beagle/ Cavalier King Charles mix

Chases lights • Steals toys from dog neighbors • Plays with toy cat • The most gentle dog

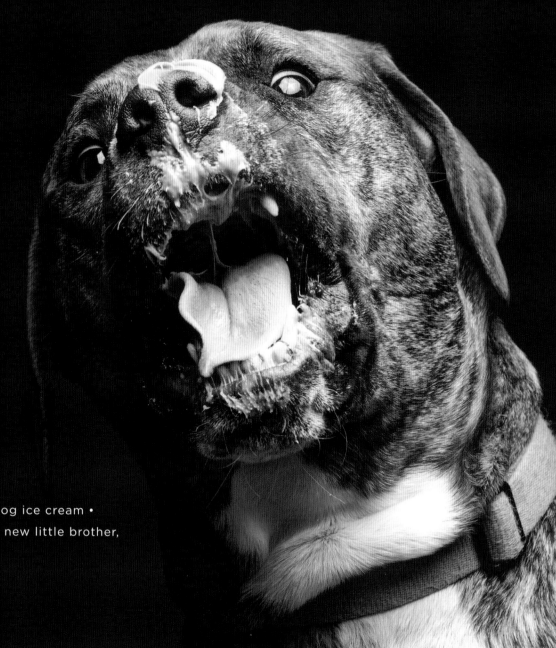

Moses

2 years old
Mastiff

Rescue • Loves dog ice cream •
Watches over his new little brother,
Grady

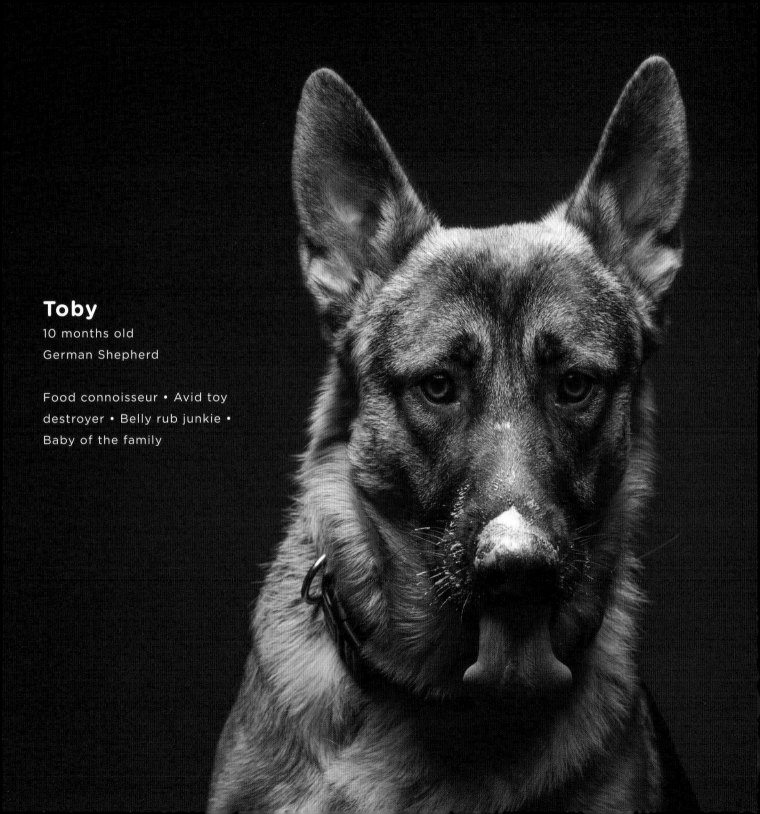

Toby

10 months old
German Shepherd

Food connoisseur • Avid toy
destroyer • Belly rub junkie •
Baby of the family

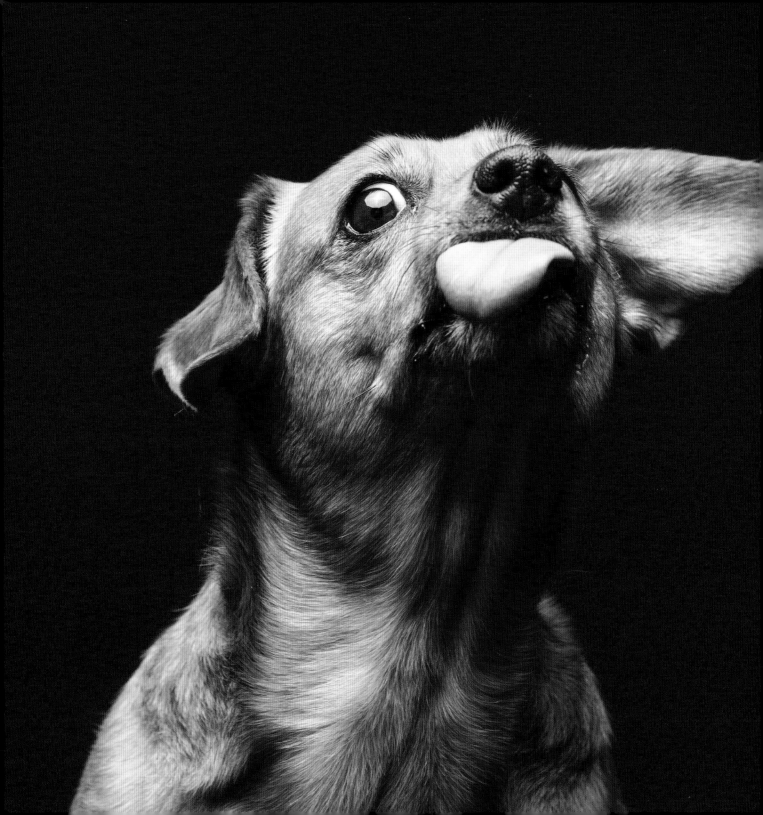

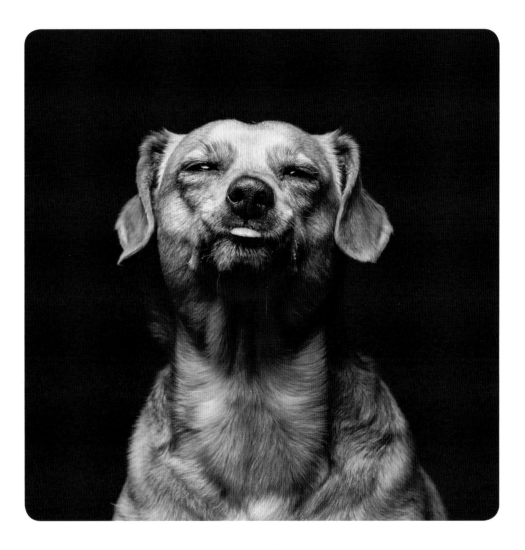

Peanut

7 years old
Dachshund/Pit Bull mix

Rescue • Extremely social • Visits nursing home, jumping up on wheelchairs and snuggling in beds • Loves to sunbathe at the beach • Has her own beach umbrella she goes to for shade

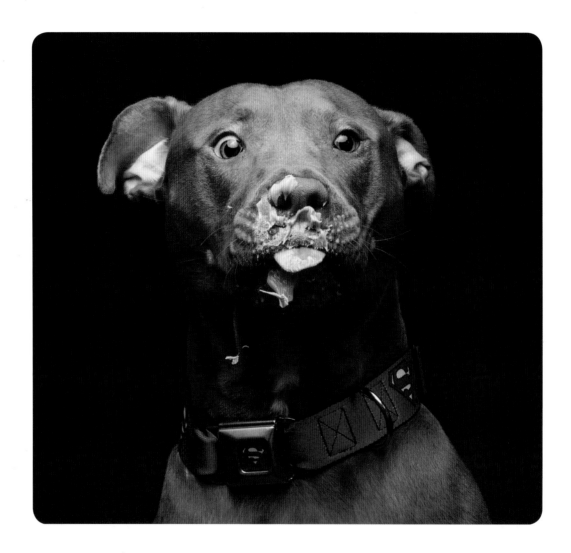

Boss Hog

1 year old
American Pit Bull Terrier

Trips over his own feet • Sleeps like a
human: head on pillow, spoons under
covers, snores • Convinced he's only
six pounds

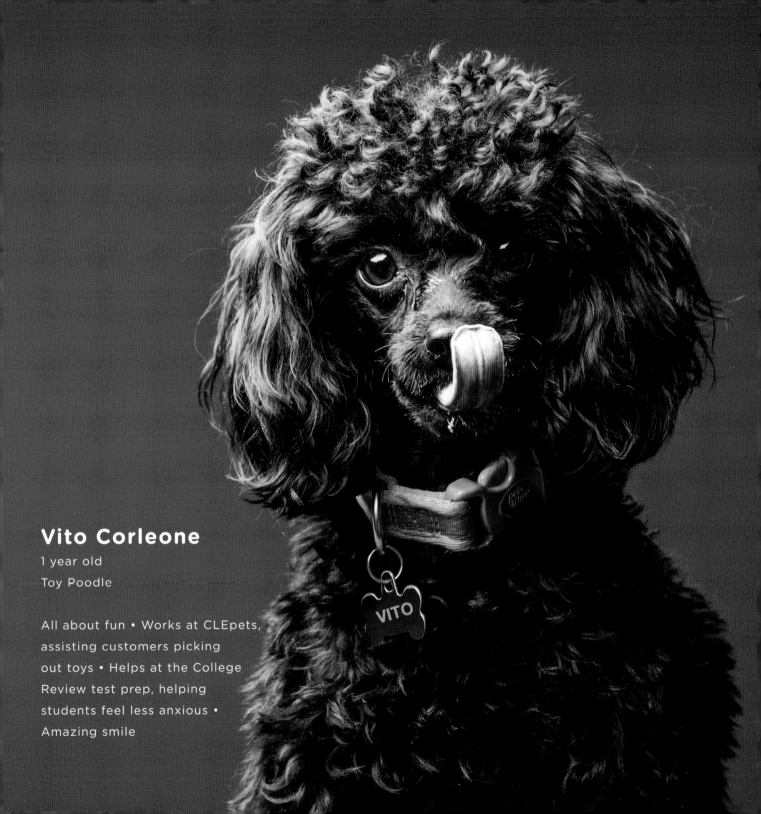

Vito Corleone

1 year old
Toy Poodle

All about fun • Works at CLEpets,
assisting customers picking
out toys • Helps at the College
Review test prep, helping
students feel less anxious •
Amazing smile

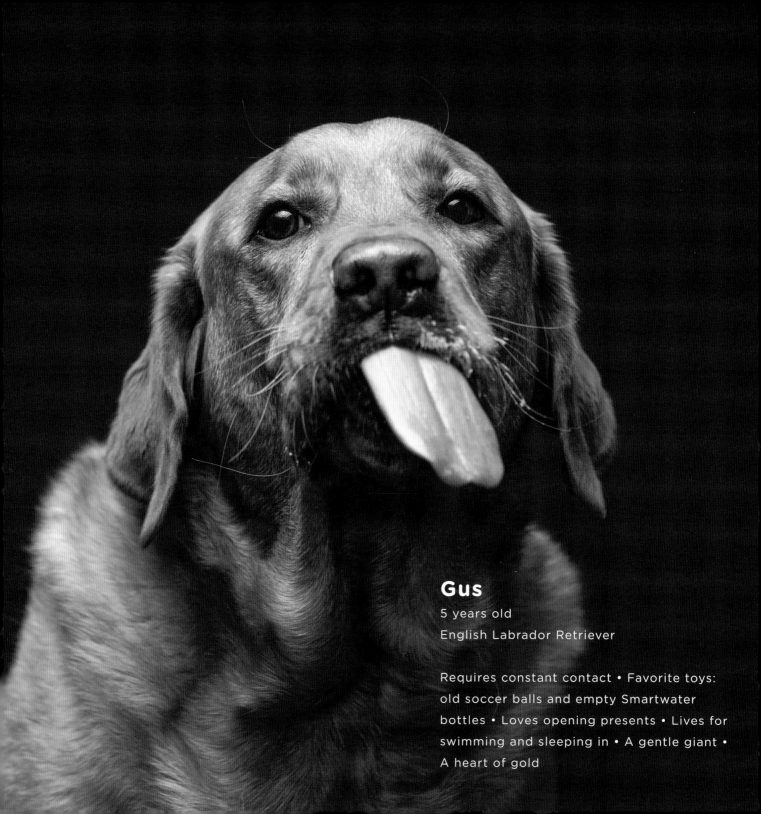

Gus

5 years old
English Labrador Retriever

Requires constant contact • Favorite toys:
old soccer balls and empty Smartwater
bottles • Loves opening presents • Lives for
swimming and sleeping in • A gentle giant •
A heart of gold

Remy

4 years old
Havanese

Enjoys watching TV • Favorite
foods are Pup-Peroni and ice
cream • Nickname: Mayor of
Pepper Creek • Loves to cuddle

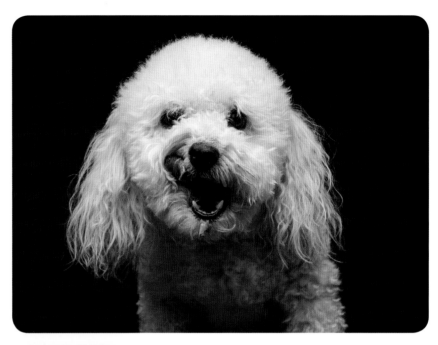

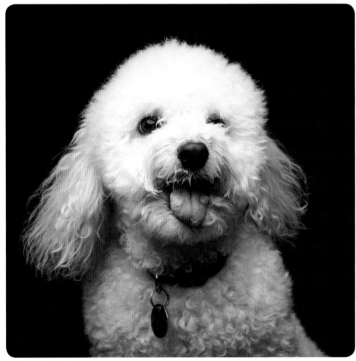

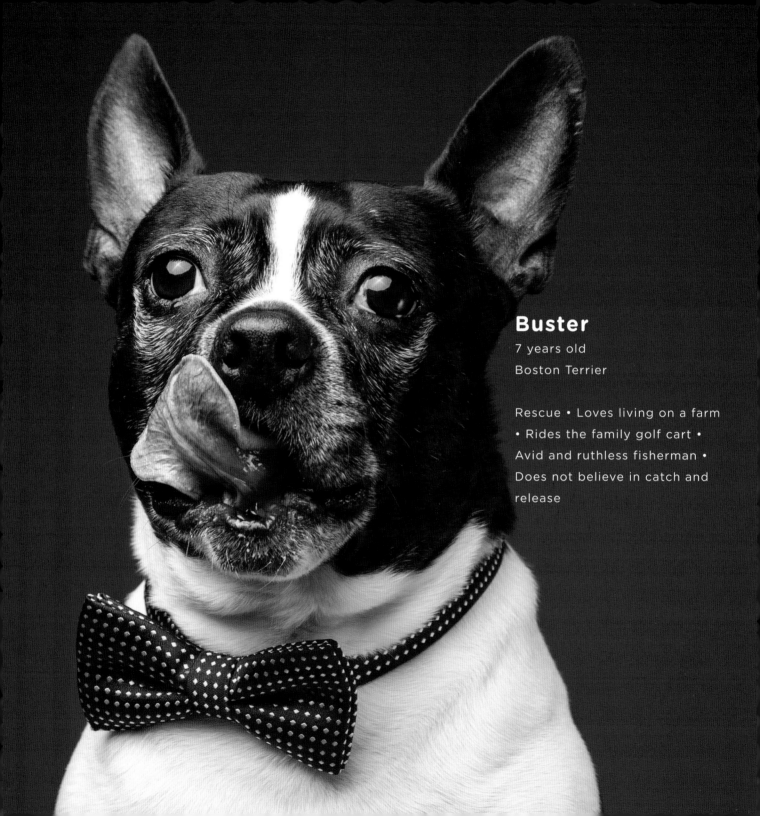

Buster

7 years old
Boston Terrier

Rescue • Loves living on a farm
• Rides the family golf cart •
Avid and ruthless fisherman •
Does not believe in catch and
release

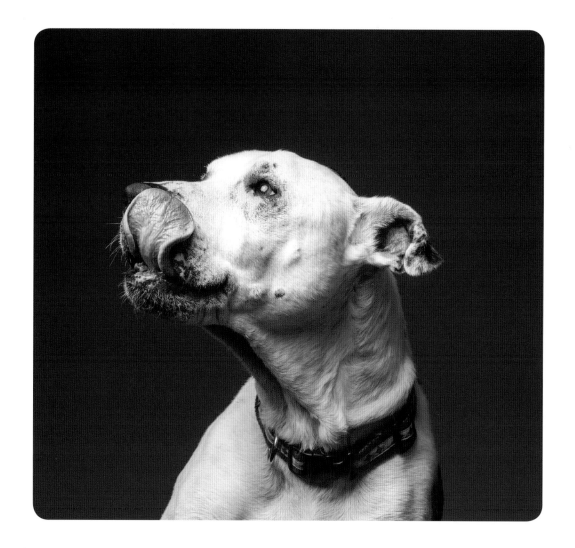

Chico

13 years old

Pit Bull mix

Rescue • Sweet old man • Still has pep in his step • Favorite activities: eating, napping, taking short walks

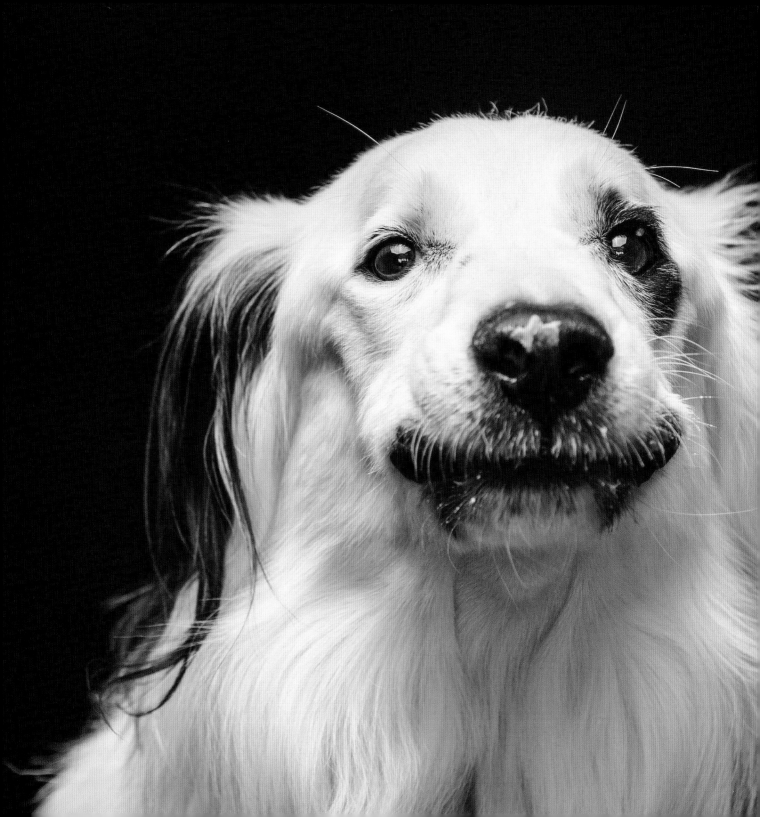

Ozzie

7 years old
Australian Shepherd/Labrador Retriever mix

Rescue • Gentle soul • Everyone in the neighborhood knows him by name • Once wandered into a local bar • When his owners found him, he was on the stage surrounded by admirers lovingly giving him French fries and hugs • Now won't walk past that bar without straining on his leash to get in the front door • Never forgets a snack

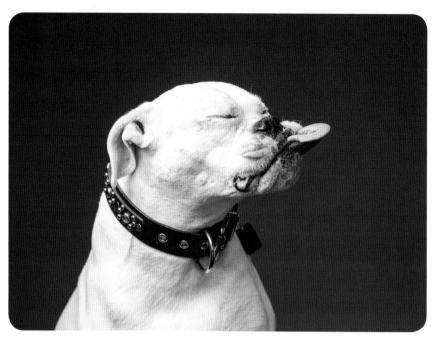

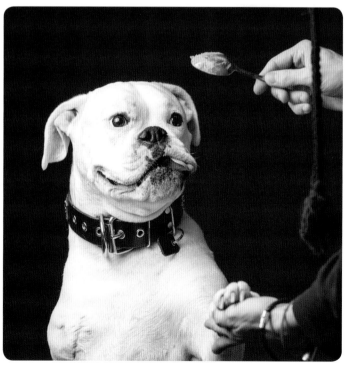

Layla

9 years old
Boxer

Found in an abandoned home • Fostered
back to health • Lost a leg • Found a
family • The goofiest dog you'll ever meet

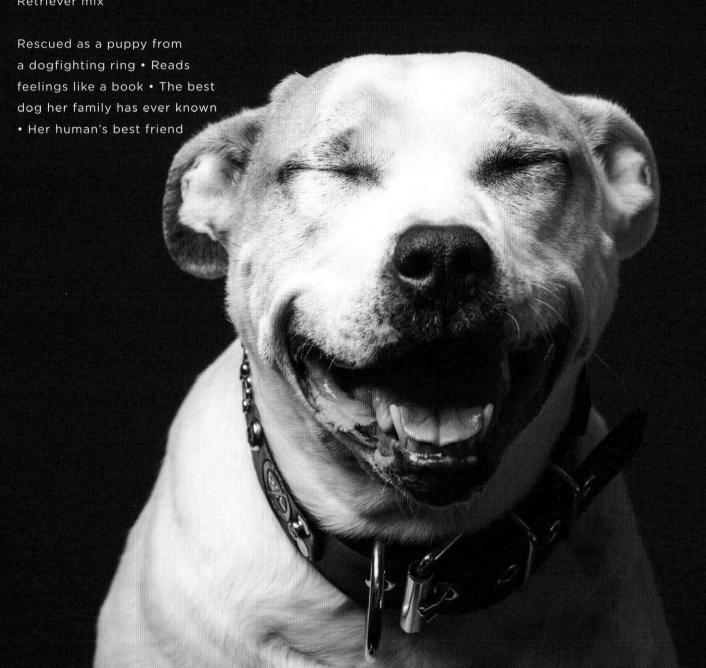

Macey

10 years old
English Bulldog/Labrador
Retriever mix

Rescued as a puppy from
a dogfighting ring • Reads
feelings like a book • The best
dog her family has ever known
• Her human's best friend

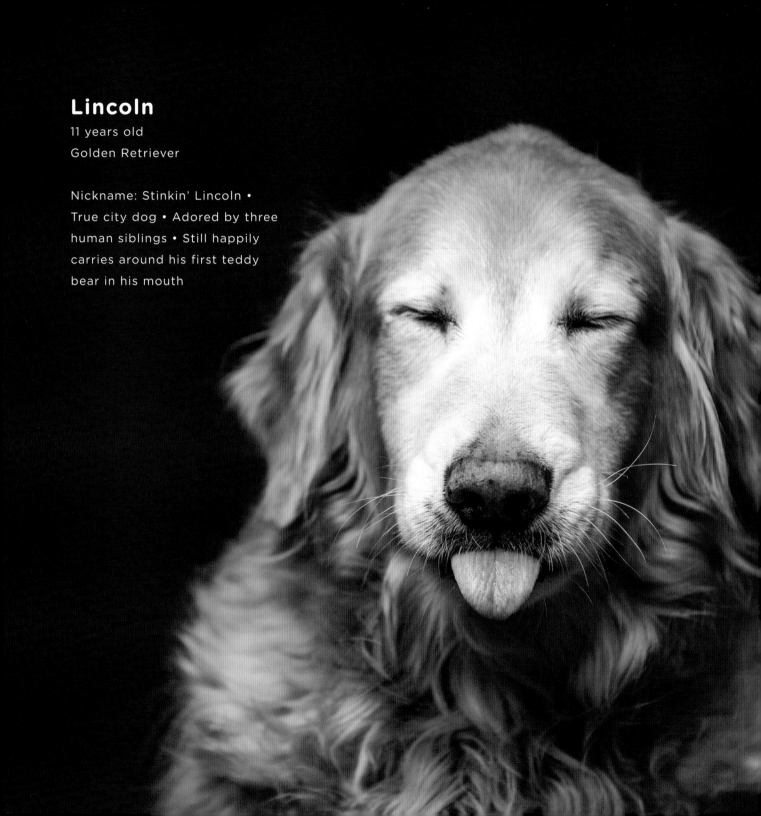

Lincoln
11 years old
Golden Retriever

Nickname: Stinkin' Lincoln •
True city dog • Adored by three
human siblings • Still happily
carries around his first teddy
bear in his mouth

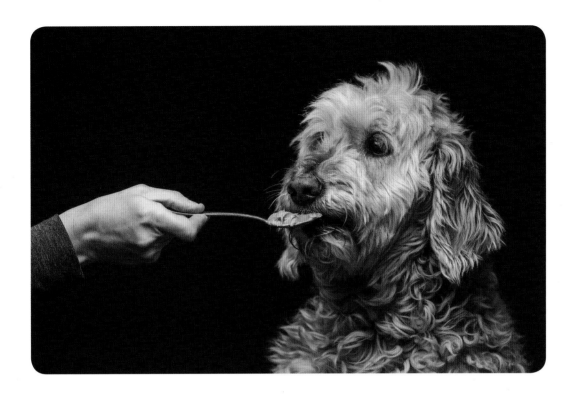

Maggie

11 years old
Goldendoodle

Enjoys car trips to Chicago with
her head out the window • Loves
to give kisses and be outside

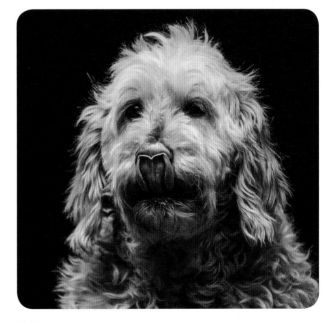

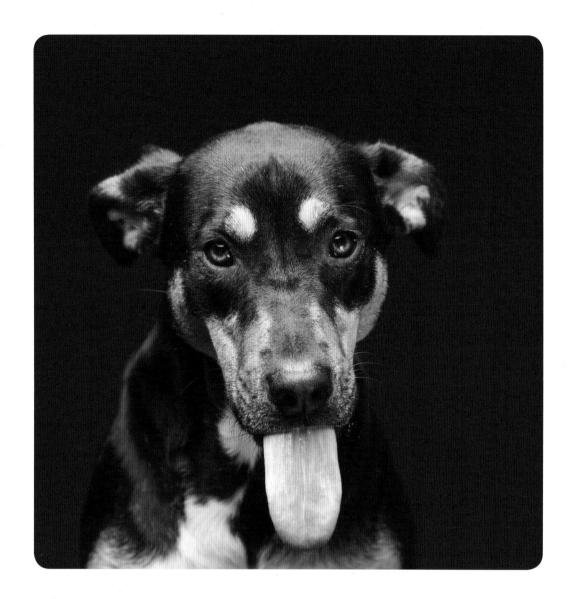

Miera

2 years old

German Shepherd/
Doberman Pinscher mix

Rescue • Heart of gold • Every new
experience is the best day of her life

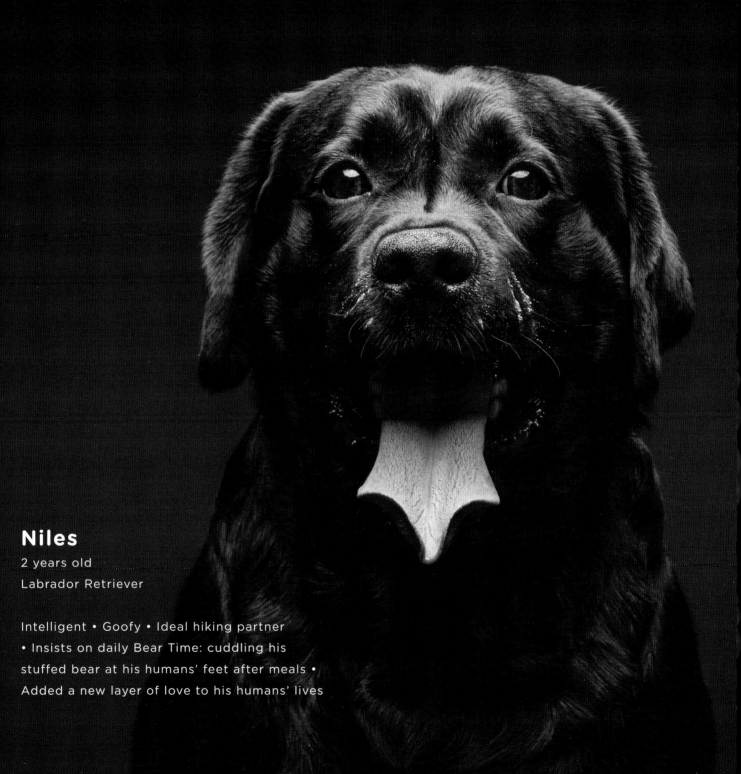

Niles

2 years old
Labrador Retriever

Intelligent • Goofy • Ideal hiking partner
• Insists on daily Bear Time: cuddling his
stuffed bear at his humans' feet after meals •
Added a new layer of love to his humans' lives

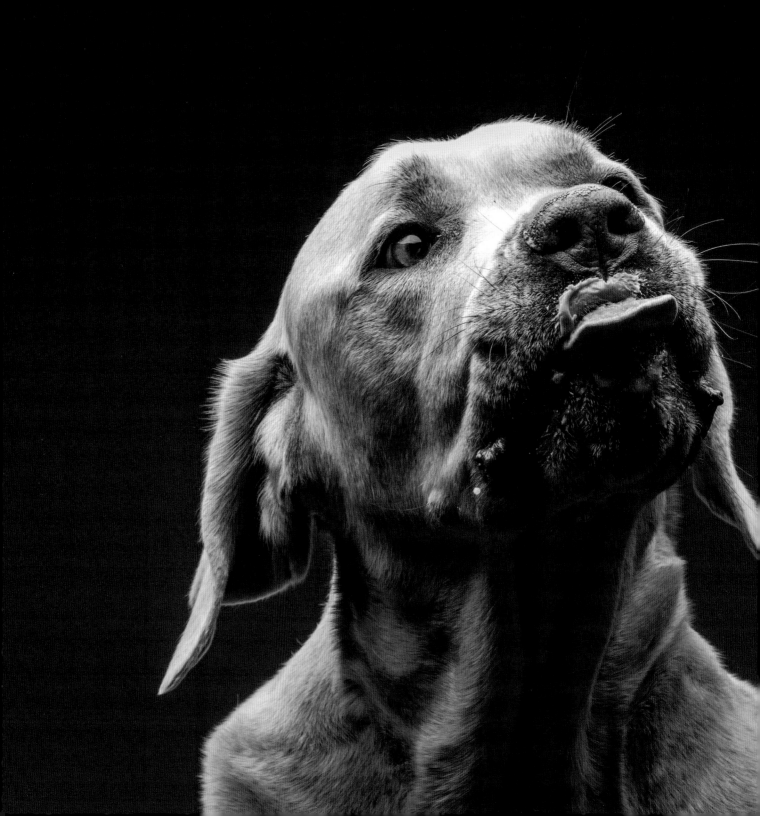

Oberon

8 years old
Cane Corso

Aids in training and rehabilitation of dogs with problem behaviors • Provides a calm, balanced energy • Helps even the most nervous dog to relax • Works with Hugo and Dutch

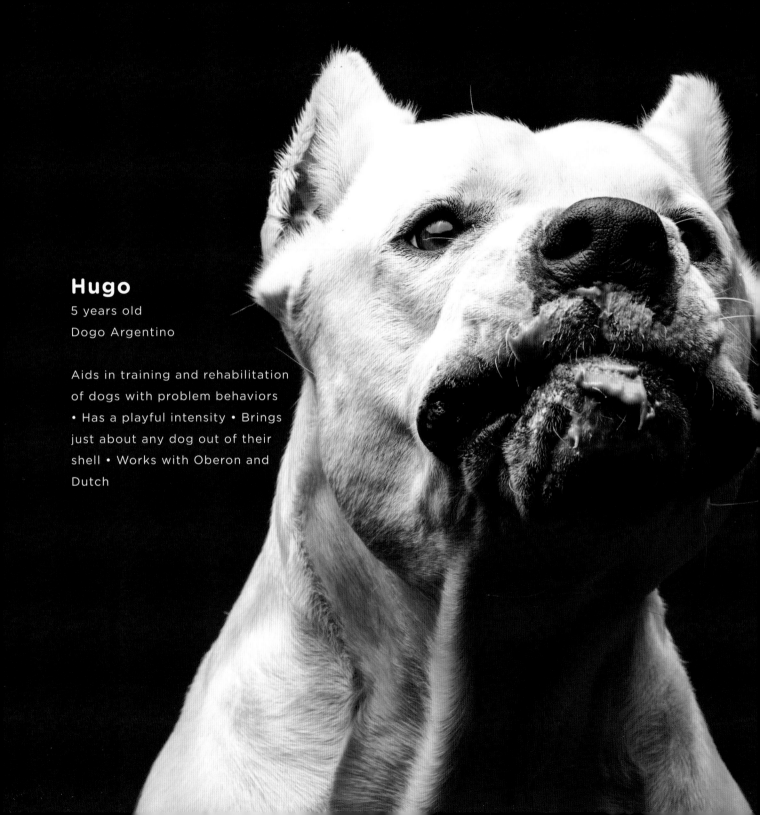

Hugo
5 years old
Dogo Argentino

Aids in training and rehabilitation of dogs with problem behaviors • Has a playful intensity • Brings just about any dog out of their shell • Works with Oberon and Dutch

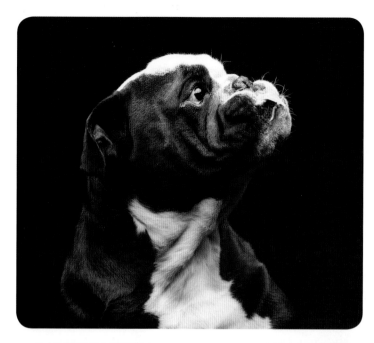

Dutch

3 years old
English Bulldog

Aids in training and rehabilitation of dogs with problem behaviors • Small but tenacious • Works with Oberon and Hugo

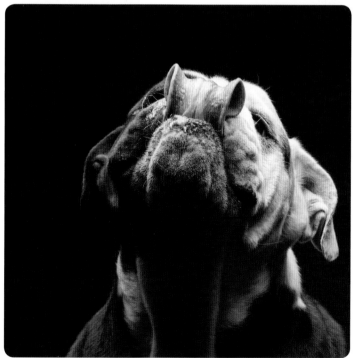

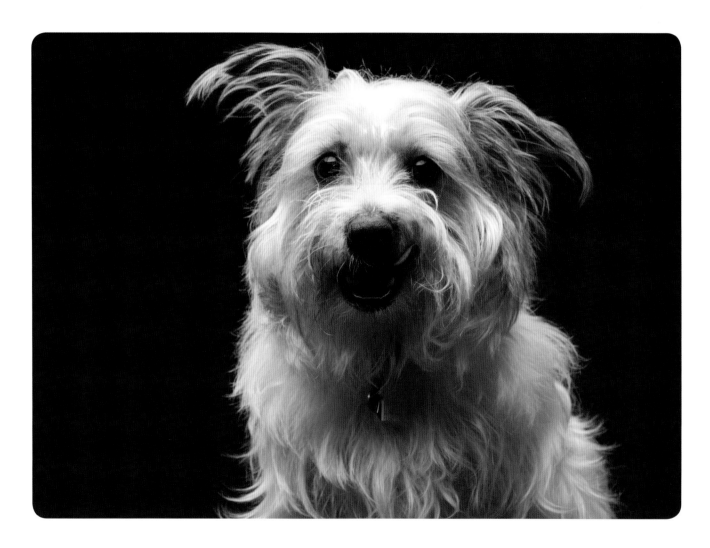

Myla

2 years old
Jack Russell/Shih Tzu mix

Rescue • Cuddly • Loves everyone
(except cats) • Likes walks to local ice
cream shop on lazy Saturday nights •
Favorite flavor: vanilla

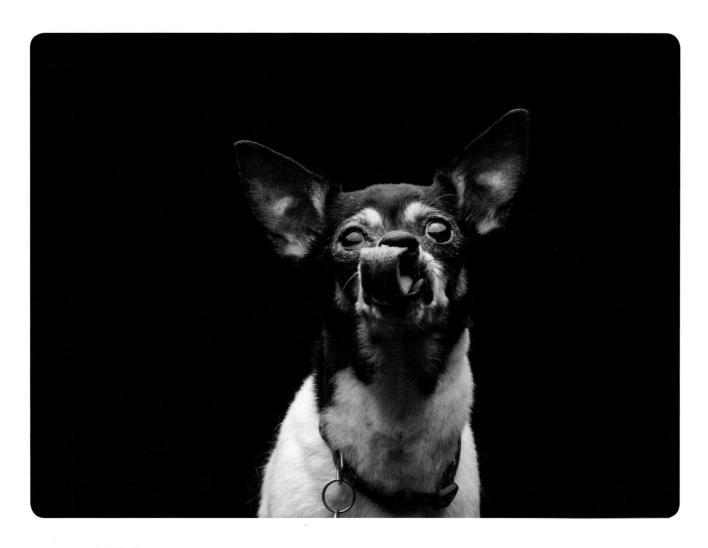

Niki

15 years old
Toy Fox Terrier

Curious • Fearless • Tenacious •
Loves peanut butter and ice cream •
"Speaks" her mind

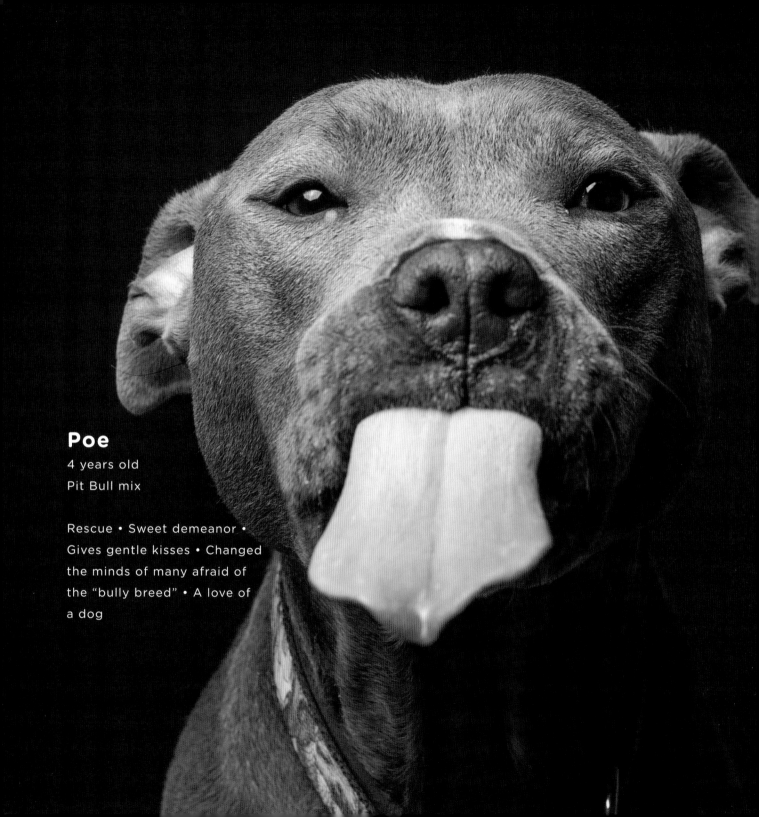

Poe

4 years old
Pit Bull mix

Rescue • Sweet demeanor •
Gives gentle kisses • Changed
the minds of many afraid of
the "bully breed" • A love of
a dog

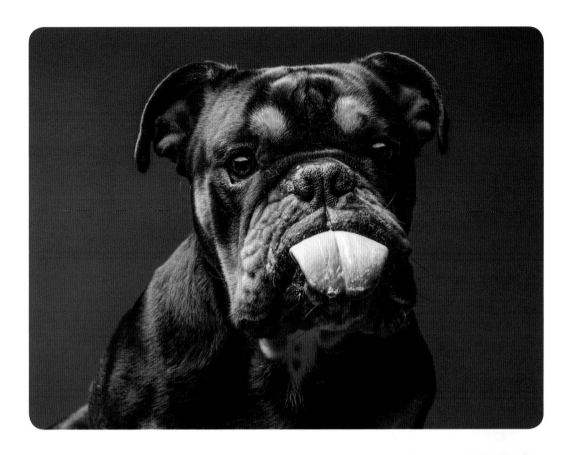

Zig

2 years old
Bulldog

Rescue • Loves being lazy •
Favorite snacks: peanut butter and
frozen fruit • Wakes himself up
with own loud snores

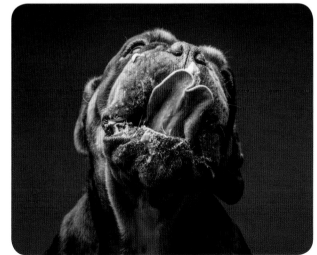

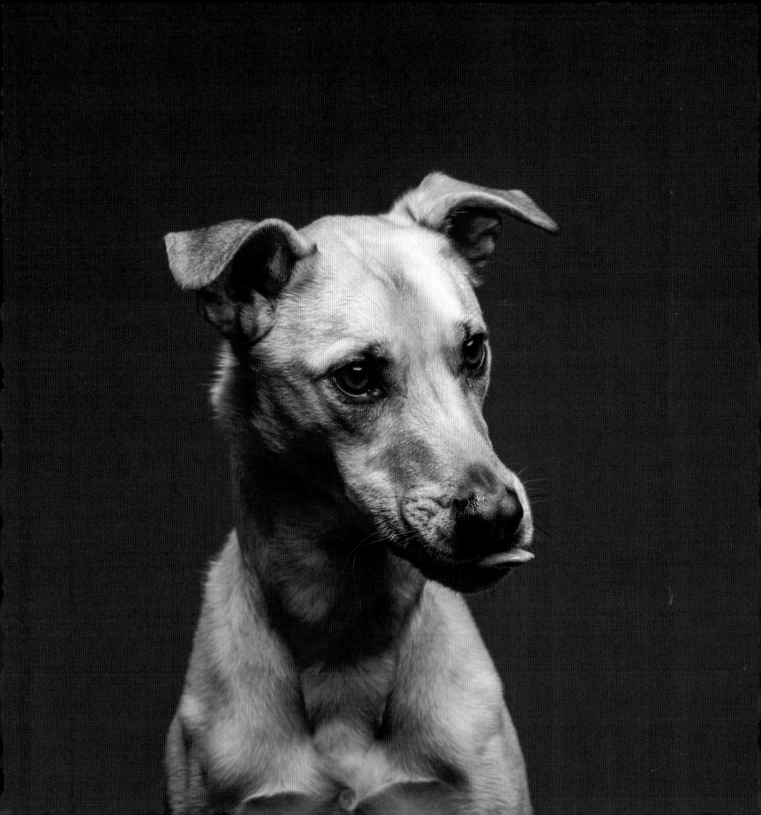

Please note the following about dogs and peanut butter before you consider giving it to a furry friend of yours:

In most cases, a little bit of peanut butter is perfectly fine for dogs. It's generally safe, and it's even a good source of protein, vitamins, and healthy fats.

Too much of anything, including peanut butter, is not good for dogs. **The dogs in this book were given small amounts of peanut butter during shoots that lasted 5 to 10 minutes on average.**

All-natural peanut butter, made up of peanuts and salt, is ideal. Avoid any peanut butter that contains xylitol. Xylitol can be very dangerous to dogs. ALWAYS check labels before giving any type of food to your dogs.

Consider consulting your veterinarian prior to giving peanut butter to your dog(s). Just like with humans, a few dogs may have peanut allergies even though most dogs have no problems with peanuts. If your dog appears to have a bad reaction to eating peanuts at any time, contact your vet immediately.

Acknowledgments

I would like to express my gratitude to the many people that made this book possible and for those that have supported me over the past few years.

Thank you Kristen, Mom, Dad, Brian, Scott, Dr. Katie, and all my clients, friends, and family.

Thank you to the staff and volunteers at the Cleveland APL, Muttley Crue, Friends of the Cleveland Kennel and all the wonderful rescue organizations I've had the opportunity to work with. You are amazing people that do great work.

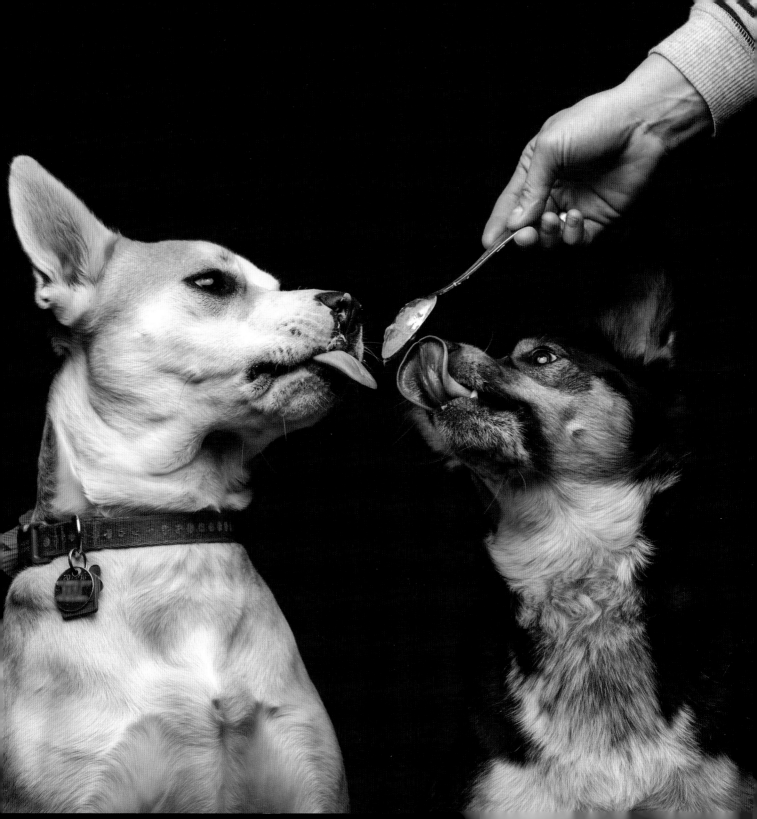

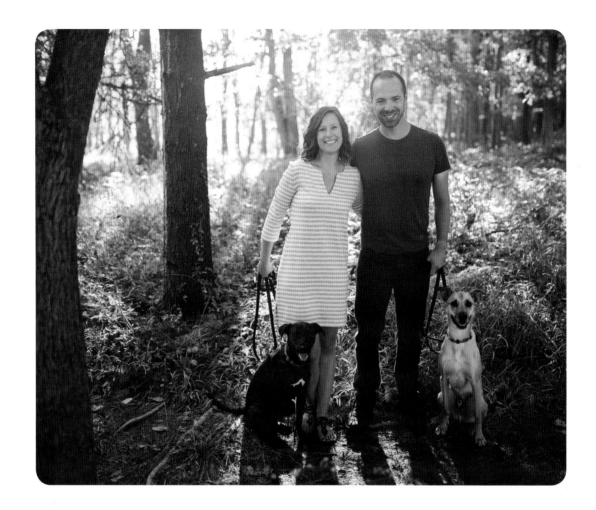

About the Author

Greg Murray is a pet photographer and rescue animal advocate based out of Cleveland, Ohio. He lives with his wife, Kristen, and their two rescues, Leo and Kensie.